The Picture Book

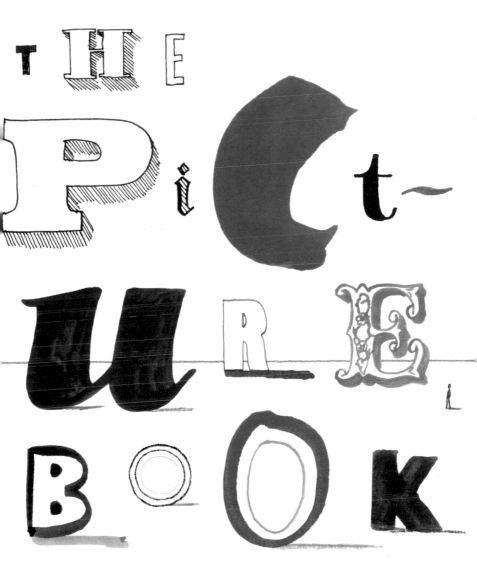

Contemporary Illustration
Edited by Angus Hyland

741.6

41882/10

Contents

Introduction
Angus Hyland

About a year ago I walked into one of those trendy gift-shops that sell design icons and quirky retro goods styled to appeal to our post-modern ironic tastes. One object that caught my attention was a coffee mug with a cowboy illustration. I can't quite explain what it was about this particular '50s-style drawing – whether it was the colour or the particular style of line – but something about it fascinated me. I had one of those 'time-travel' experiences that we all have when we catch a certain smell or ambience, or very occasionally through a recognised image – when something instantly familiar, perhaps even intensely loved, that has drifted out of our consciousness is then catapulted into our present experience. Of course, this can happen with a photograph, but for some reason I'm not sure I can fully explain, the emotional investment that we put into the artwork we cherish as children is more powerful, more fantastic, and more real. Of course, the feeling faded as quickly as it had arrived and I didn't buy the mug. For a long time I forgot about this picture of a cowboy astride his horse, complete with his ten-gallon hat and sheepskin chaps. Lately, however, I have come to regret not buying the mug partly because I want to experience once more that transporting feeling, but mostly, I now realise, because I want to pass on my identification with that image to my children – a gift from one child to another.

So what does a small cowboy image have to do with illustration? It set me thinking about the importance of childhood experience, the freedom to dream, and the freedom to recreate those dreams for others. These things lie at the heart of picture-making. It is evidenced in the text from the artists showcased in this book that the link between drawing, childhood play and dreaming is a strong one.

'I've been drawing all my life.' Harriet Russell

'I have drawn since I was a child and remember feeling most comfortable and contented when drawing.' Astrid Chesney

'I spend most of my life in a perpetual dream world, my mind drifting through landscapes where narratives start to form.' Kerrie Jane Stritton
'Verbal communication was very difficult for me as child; I constructed my own visual world to inhabit.' Roderick Mills

Whether through reading superhero comics or doodling horses and German army helmets on the margins of their schoolbooks, the experience of these artists is that the imagination is often best captured and expressed through drawing. It would be very wrong to suggest that illustrators suffer from some sort of arrested development and that this has led them to their chosen career. Evidently, drawing is a gift – something that is discovered at an early age. These illustrators have, each in their unique way, harnessed the need and the freedom to express themselves through drawing, or to use drawing as a means to 'play'. And such 'play' is deeply revealing. Sara Fanelli quotes Plato: *'You can discover more about a person in an hour of play than in a year of conversation.'* Playfulness is a strong and recurring undercurrent through this body of work.

It is fair to say that we first engage with art or picture-making at an early age through children's books. Illustration, rather than what we think of as fine art, forms the basis of our aesthetic education. I can trace my own appreciation of Picasso backwards via Hockney to Escher, to Ardizzone, to Arthur Rackham, whose illustrations for Kenneth Grahame's *The Wind in the Willows* have a similar grip on my imagination as the image of that cowboy. It is the first book I remember consciously enjoying. While the text engaged me, it was Rackham's illustrations that enabled me to enter a new world. They illuminated the story, opening a window into another dimension.

The combination of words and pictures is nothing new: illustration has a history that stretches back beyond Gutenberg. Early handwritten manuscripts were ornamented and illuminated, bringing

together the sacred (in the text) and the secular (in the pictures). Illuminations of religious writings would not only illustrate the content of the text: they also set it within the context of the secular world with illustrations of contemporary figures ploughing fields, for example. The monk artists of the mediaeval scriptoria are the ancestors of the modern illustrator.

Six years ago I edited a book entitled *Pen and Mouse* that looked at the role of the illustrator in relation to the new technology of computer-generated images. The Apple Mac was starting to play an integral role in the renaissance of illustration, and *Pen and Mouse* sought to define the dichotomy between this emerging digital discipline and traditional handcrafted artwork. Since then, the wealth of technology available and the emergence of a new generation of computer-literate artists have meant that illustrators are likely to carry a portfolio of images made using pens, ink, gouache, laptops, markers, rubber stamps, scanners and digital cameras. The fruits of this emergence of a formerly niche discipline are there for everybody to see: popular culture is replete with the works of these diverse commercial artists. Illustration in its many forms has become more visible in everything from editorial, design and fashion publicity, to advertising, music, television and graphics. It is hard to imagine opening a quality newspaper without coming across myriad drawn images ranging from the decorative to the political. *The Picture Book* celebrates a flourishing artform.

Michelle Thompson___

'I illustrate because I love working to a brief and a tight deadline. I work well under pressure, so the more commissions I have the better the results. I love the feeling of having to produce an image in a few hours. The adrenaline rush and then the satisfaction of pressing "send" at five o'clock and sitting down with a glass of wine. I enjoy what I do but I have always treated it as a job, more so since having my son. I hardly ever produce personal work. My whole motivation is focused on the deadline and how much I'm being paid. Well, at least I'm honest! I tend to have favourite elements like a tiny scrap of paper, scribble or figure which I will use again and again whatever the commission and that's as personal as my work gets.'

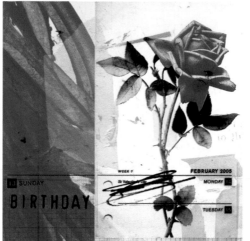

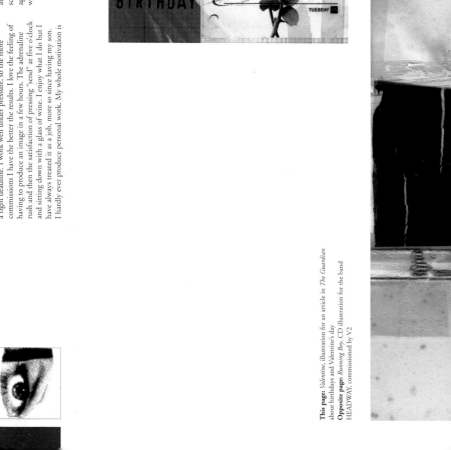

This page: *Valentine*, illustration for an article in *The Guardian* about birthdays and Valentine's day
Opposite page: *Running Boy*, CD illustration for the band HEADWAY, commissioned by V2

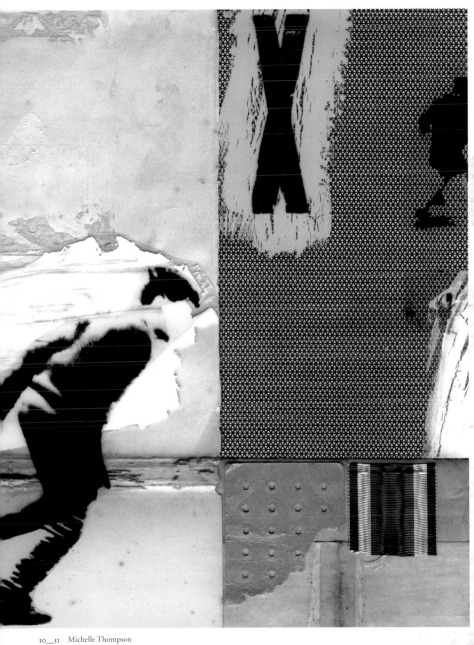

Michelle Thompson

Opposite page: *Crush*, illustration for an article in *The Guardian*
This page: *Other People's Children*, illustration for an article in
The Guardian on not loving your partner's kids

Kate Gibb___

"Because I can't do anything else" always seems a sufficient reply to the "Why do you do what you do?" question. "I kind of make it up." That's the usual response to "How do you do what you do?" Both may seem a little blasé but really it's the truth. The kind of silkscreen printing I'm inspired by relies on chance, hiccups and accidents to provide the individual qualities that make up each piece. This is what keeps it exciting, a process to be continually explored and played with. Work is play to me for the majority of my time and the rest of the time it is a great way to make a living. I consider myself extremely lucky.'

Come with Us, sleeve artwork for the third single from the Chemical Brothers' fifth album of the same name

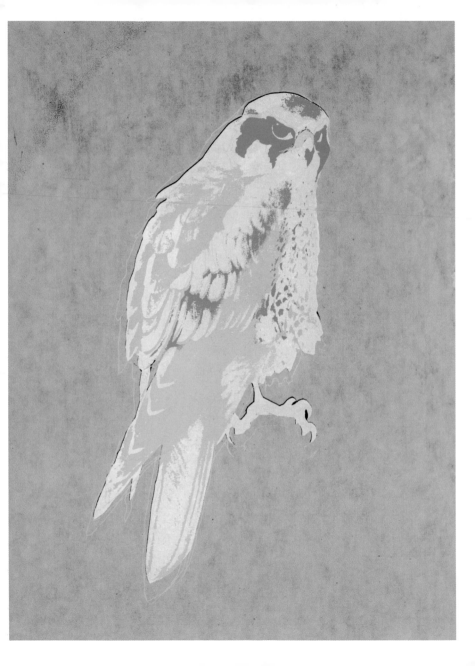

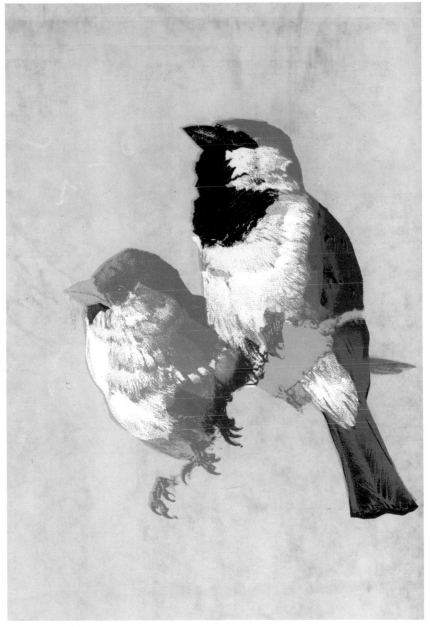

Both pages: *Liberty birds,* personal project

Ian Wright___ 'I get excited by what could be. I need to get my work somewhere new. I want to keep it raw. I like to play. I want to do what is in my head. I want to surprise myself. I want to get excited. I prefer colour. I prefer black and white. I look for a happy accident. I often let the materials dictate the outcome. I always want to change direction. I like a random, awkward element. I want to go big. I enjoy collaboration. I like noise. I am usually unimpressed. I need to hear music. I need to read fiction. I need to see more pictures. I will always be curious. I want to be here for the long haul. I need to know what happens next. I want to keep the faith. That's why I keep going.'

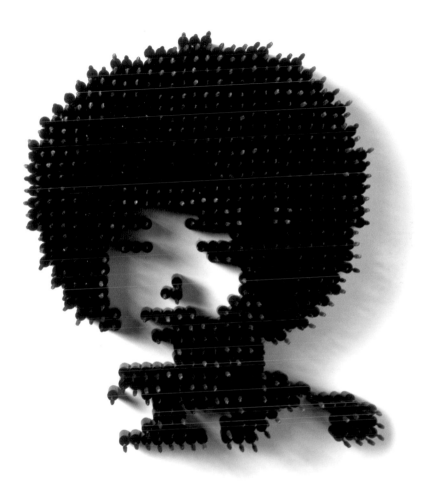

Opposite page, left: *Larry Levan*, hama beads, private commission
Opposite page, right: *Chuck D.* of Public Enemy, private commission
This page: *Angela Davis '1000 Lashes'*, portrait made from Mac mascara
brushes, produced for US magazine *Black Book*

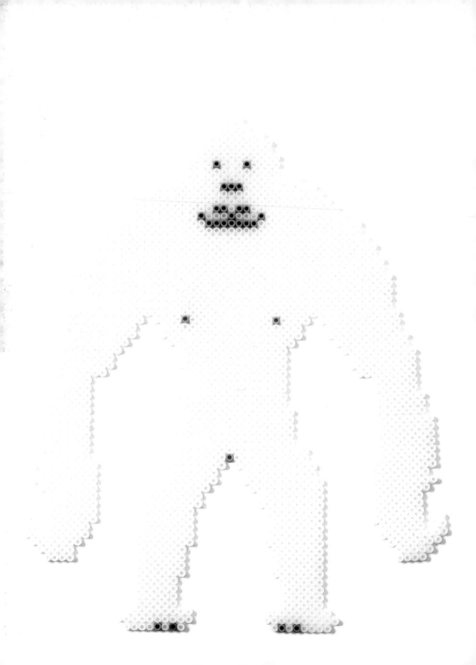

Opposite page: *Ghost gorilla*, original maquette, produced for Issey Miyake NYC
This page: building the *Ghost gorilla* installation, after the original maquette, for Issey Miyake NYC

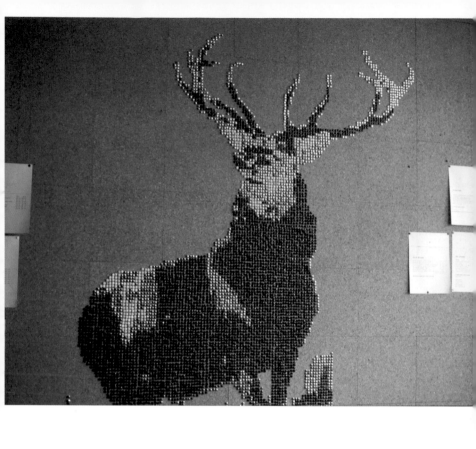

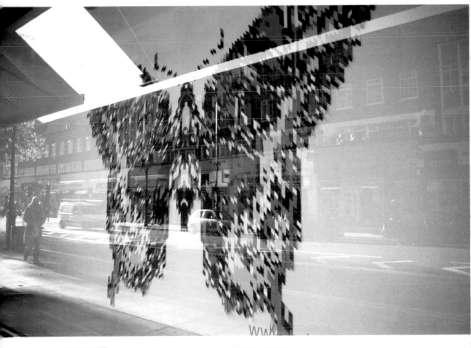

Opposite page: *Monarch of the Glen*, after Landseer, drawing pins, created for the Konstam restaurant, London
This page: *I get high when I see you walk by*, ribbon butterfly, created for Brinkworth Architects, London

Travis Chatham___

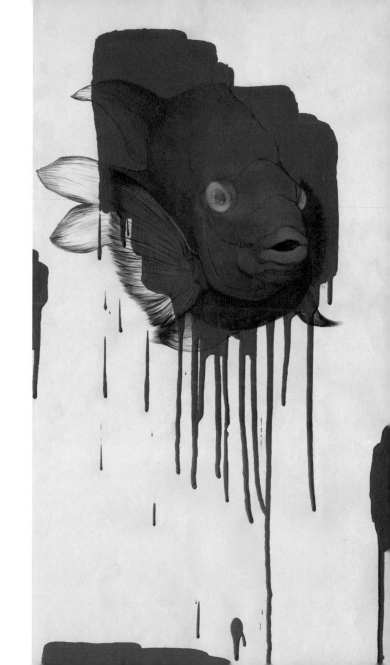

'At age 12 I fell flat on my face trying to drop in on my first half-pipe: a ten-foot Vert Ramp. I figured if I pumped all the way to the top and did a backside grind, I could drop in. Well, I was wrong. Man did that hurt! That experience took me a couple of years to get over. I eventually did and still try to skate whenever I can. In eighth grade, my band played the local talent show and kicked ass. All the girls were screaming. We did two originals and that version of "Signs" that Tesla did a way back. Throughout those years I've been drawing and painting. Coming up with artwork for my first pro skate deck, or for our first album cover. Remember those Iron Maiden album covers? I drew them over and over again. Anyway, these are the things that inspire me. They did as a kid and still do today. Other inspirations are my wife and my students. They put a smile on my face every day.'

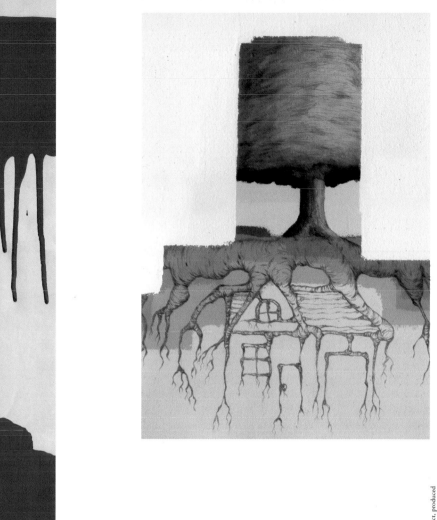

Opposite page: *Garibaldi*, personal project, produced for an art festival in Avalon, Catalina Island

This page: *Bloomberg tree-house*, produced for *Bloomberg Wealth Manager* magazine

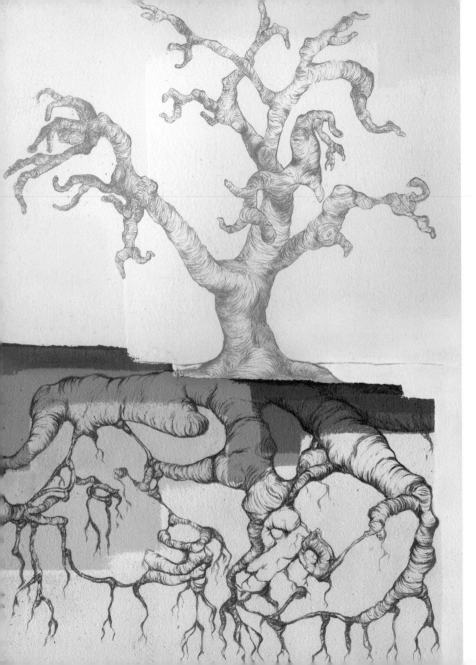

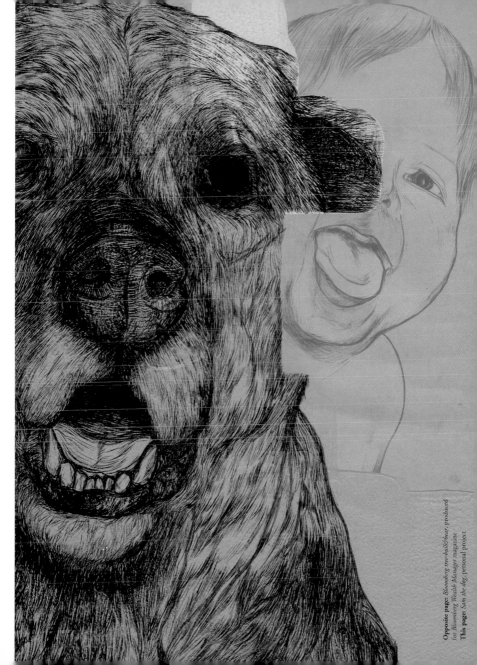

Opposite page: *Bloomberg two-fold/three*, produced for *Bloomberg Wealth Manager* magazine
This page *Sam the dog*, personal project

'When I was at school, maybe ten years old, I used to draw in the margins of my exercise books, filling them completely with tiny drawings. They would sometimes spill into the page amongst the sums or sentences so in the end my teacher decided to give me a special book to draw in. I'd get my work done and then set to work in my "Doodle Book". I filled lots of them. I think being given that book was an important moment for me: it was my first sketchbook. I still draw lots of little things. My aim with my work is to communicate my idea as simply and directly as possible. A drawing might be detailed but I try to make everything clear and understandable. It might look nice but it's not about making it decorative. It probably comes from drawing comics where I "write" with a mixture of words and pictures.

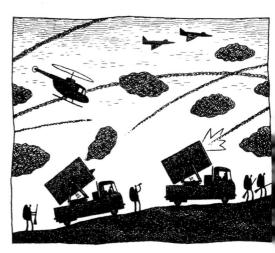

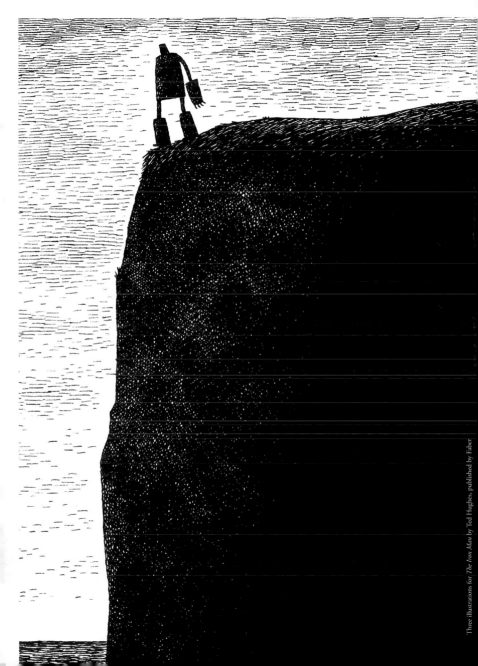

Three illustrations for *The Iron Man* by Ted Hughes, published by Faber

Zissou___　　"What if...?" Welcome here.'

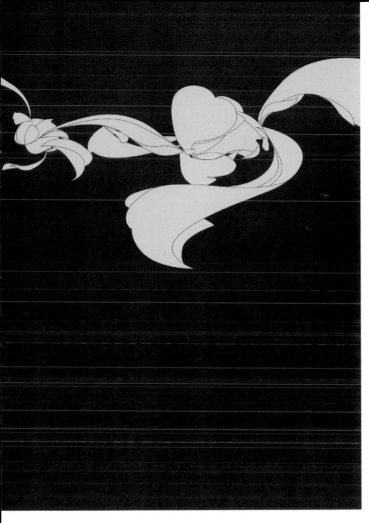

Main image, opposite page and this page: *Escape Dippity* by Zissou
This page, bottom: wall graphics for hair salon 10500 by Supernatural studios, of which Zissou is founder and Creative Director

Jo Ratcliffe___

'I came across illustration by accident really. I was in the fortunate position of living with an art director who asked me to make some drawings for her. After studying "fine art" at college I was under the impression that everything I produced must have a well thought-out concept rather than just be a pretty picture and, back then, you could have found a good drawing and scored more points for the fact that it was "found" art and you were so bloody clever. Not that there is anything wrong with that but it's covered. And apart from that I would rather be the one who loses the image and sees it regurgitated one day (I live in hope). So that's what I did. In the meantime you will have to do with the originals.'

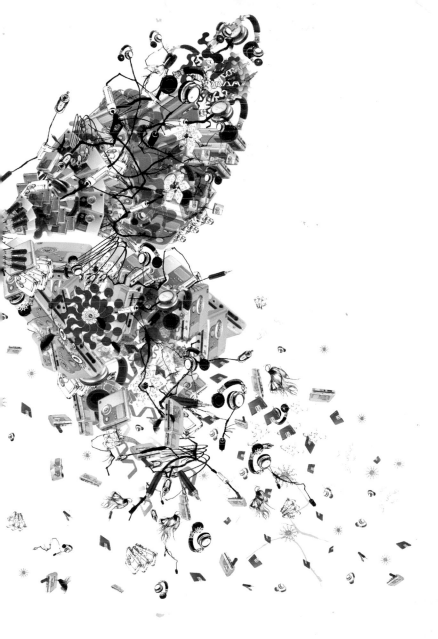

Butterfly, produced for Sony Walkman

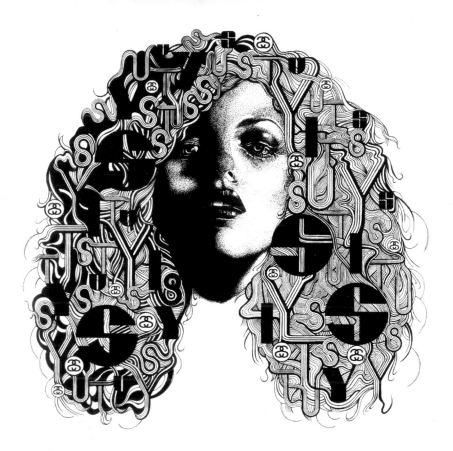

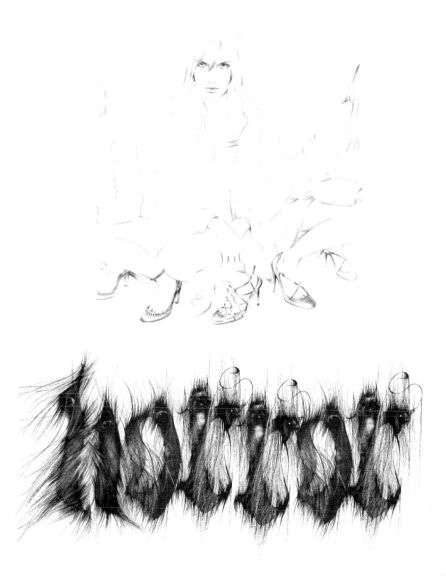

Jasper Goodall___

'I spent about five minutes on my portrait – which is much more than I want to spend writing about myself. God knows why I draw. Sometimes I hate it, very occasionally I love it – I'm still in the process of working out why I do it. A great piece of work makes me happy ... for a very short time, so consequently I must do another and another to stay happy. I guess somewhere I must imagine that there will be some kind of lasting happiness to be found from doing a kind of über

artwork – the ultimate piece of work that makes me happy forever. Sadly I know this is just my unrealistic dream and I must find happiness by making peace (with myself) – not art.'

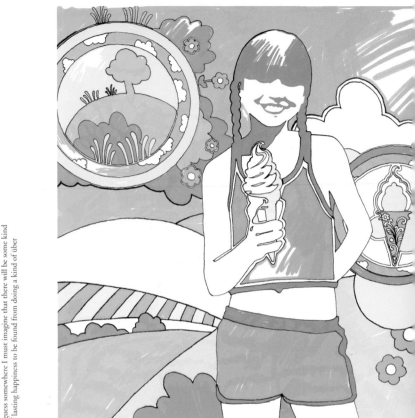

Opposite page: *Vanilla*
This page: *Bubblegum*
Both for *The scratch 'n' sniff EP* by Future Loop Foundation

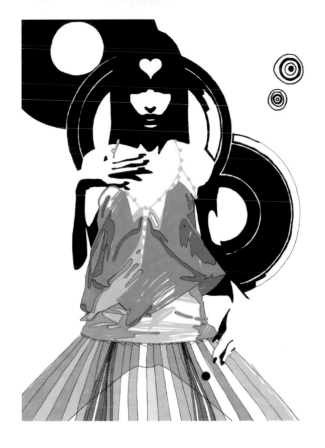

Jonathan Tran___

'It's only been a few years since I graduated but in that time I've been lucky to have carved out a career in doing what I enjoy. A big chunk of that time was trying to find what kind of work I wanted to produce. I actually owe a lot of what I do to a student who put out a fake advert to commission work for a magazine that didn't exist. Unknown to me at the time, the commission was actually part of the student's finals and I ended up creating a series of work that I never dreamed of doing. It was so different from what I'd done before. From that point on, I have been shaping and developing that work into what I do now. I can only guess what the future holds for me but I hope that's the last commission that pays me a pint of bitter and a packet of pork scratchings for my efforts.'

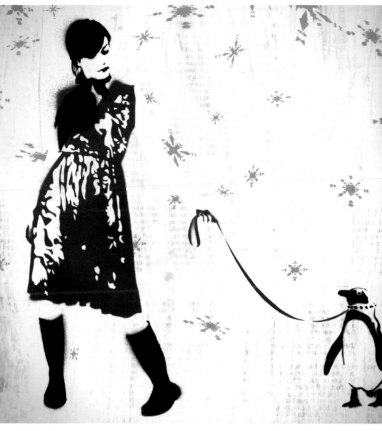

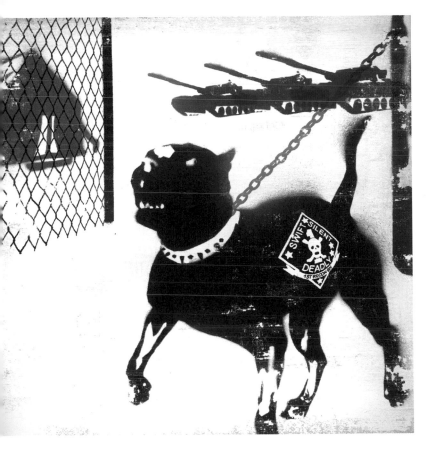

Opposite page: *Pet Penguin*, personal project
This page: *US Marine Dog*, for a *Big Issue* article, 'Dogs of War'

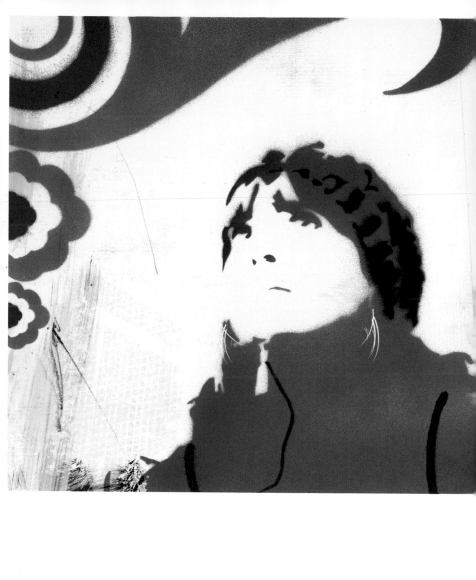

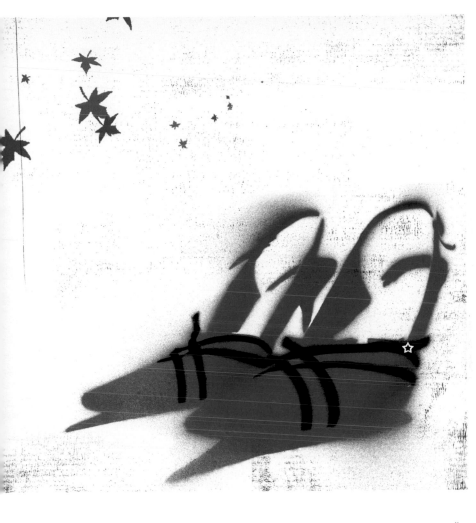

Opposite page: *Journey,* personal project
This page: *Red Shoes,* personal project

Nick Higgins____

'Whatever I have been commissioned to do, I have spent a lot of time on narrative and historical projects. Vivid incidents and picturesque clashes from various times and places, often necessarily quite brutal. An intern at an agency choosing samples took a painting of men hung in trees. "Not much call..." I said. "You never know!" she said, optimistically. Several years on I thought I was right, but then I remembered the Madison Smart Bell book, *All Souls Rising*, for which I had

to turn the brutality up to 11. I can turn it off as well though, if it suits better.'

Opposite page: *Red field*, personal project
This page: *Grey field*, personal project

Opposite page: *Species, white,* personal project
This page: *Species, black,* personal project

Opposite page: *Containership*, produced for artist's website
This page: *Seaview*, personal project

Andrew Zbihlyj___

'My work: In responding to someone who once described the tone of my work as "dark" and "semi-warped" I said "fuck you"! Actually, I just smiled and offered my view that it also contains a great deal of warmth and humanity.

On illustration: I believe there exists a place for unique and challenging work outside of gallery walls.

More on illustration: At its best, illustration is a language unto itself – a visual reflection on current affairs, a meditation on the human condition and a cue for laughter. At its worst, illustration is noise.

Where I fit in: It's not for me to say where I fit in.

As an aside: Someone once posted a link to the piecofshow website describing my name, Zbihlyj, as the result of "random *Scrabble* pieces scattered across the floor". This, I have to say, is utterly true. Actually, it's not, though the correct Ukrainian spelling is Znbhylhychj.'

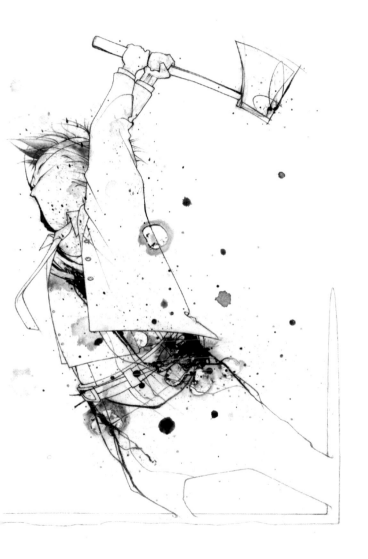

Hollywood, published alongside a David Mamet essay about artists in Hollywood in *Harper's* magazine

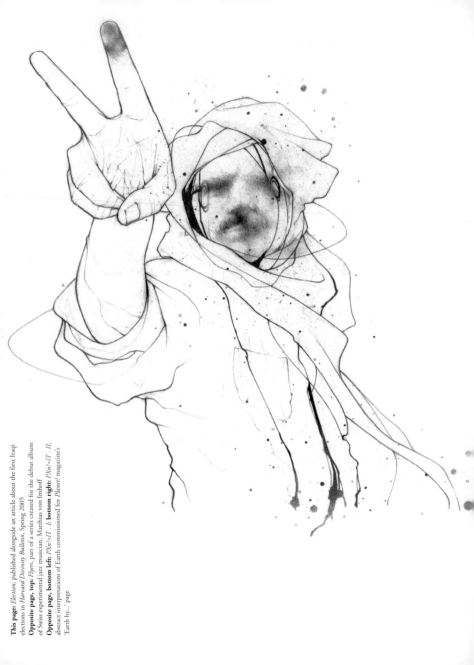

This page: *Election*, published alongside an article about the first Iraqi elections in *Harvard Divinity Bulletin*, Spring 2005
Opposite page, top: *Flyers*, part of a series created for the debut album of Swiss experimental jazz musician, Matthias von Imhoff
Opposite page, bottom left: *PXn!=!T_.I*, **bottom right:** *PXn!=!T_.II*, abstract interpretations of Earth commissioned for *Planet?* magazine's 'Earth by...' page

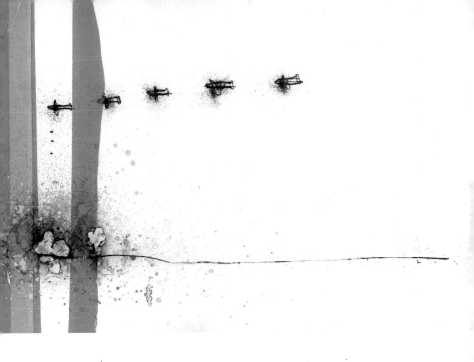

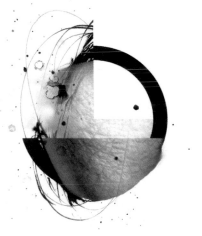

Lucinda Rogers___

'I was standing in the Castle Bookshop at the Hay-on-Wye Festival, squashed between cardboard boxes by the window to be out of the way. The colour brown seemed to suit the room. I hear conversations and outside noise while drawing but mostly am thinking about how to put on paper what is there, which is almost completely absorbing. After about two hours I started to think about going to the next drawing place and looked at my watch, tipping ink down the whole page.

Almost immediately I was quite calm about it. I realised it fell in quite a good place in the composition and that the drawing could also be about this accident.'

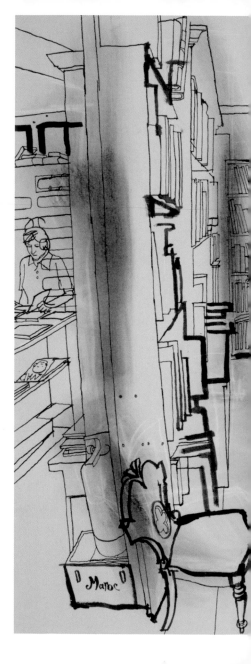

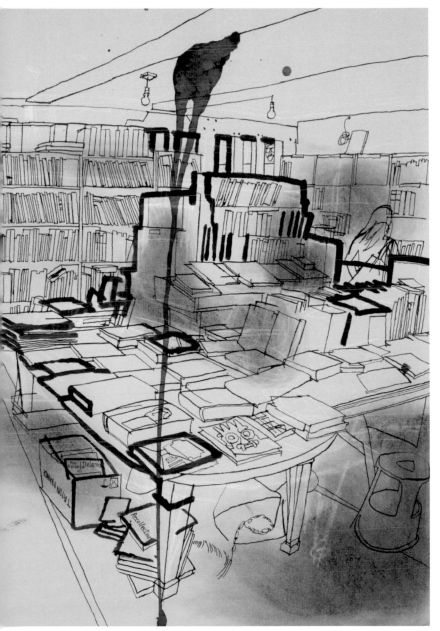

The Castle Bookshop at Hay-on-Wye, commissioned by *The Guardian* for 2006 Hay-on-Wye Festival coverage

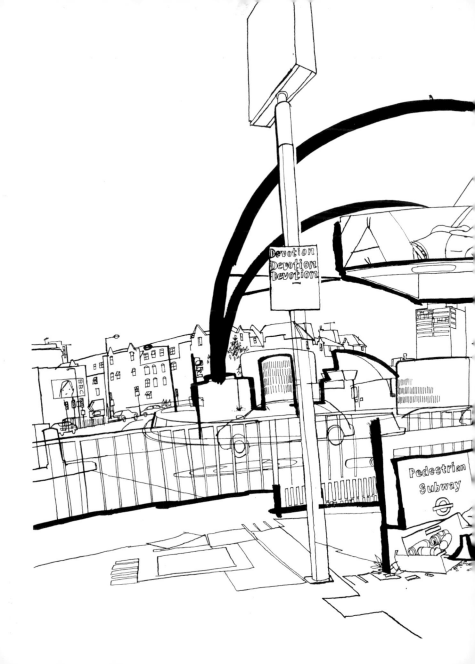

V is for Visual Clutter from *The Dictionary of Urbanism* by Robert Cowan, Streetwise Press 2005

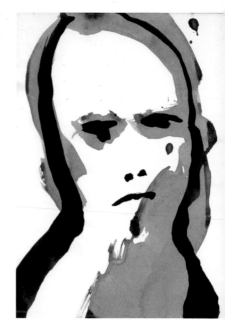

Santiago Iturralde___

'Some days I feel I am very fragile. I feel that a breeze could break me into 435 tiny crystals that would again dissolve into hundreds of small fragments, creating an infinite circle when touching the floor. If I could then reach an atomic level, the problem would be serious because this chain reaction would convert me into a human nuclear bomb. The image is odd and disturbing, isn't it? Fragility becoming a nuclear bomb...

Luckily, when I paint, I start to feel strong again and I can breathe and smile and I can think of the world.'

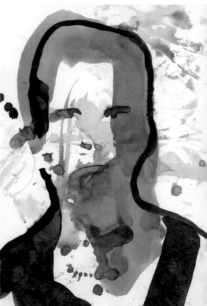

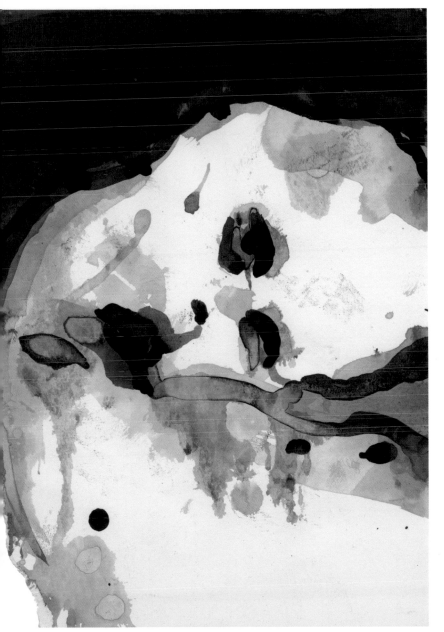

Opposite page: two works entitled *Guilty*, personal project
This page: *Drowning*, personal project

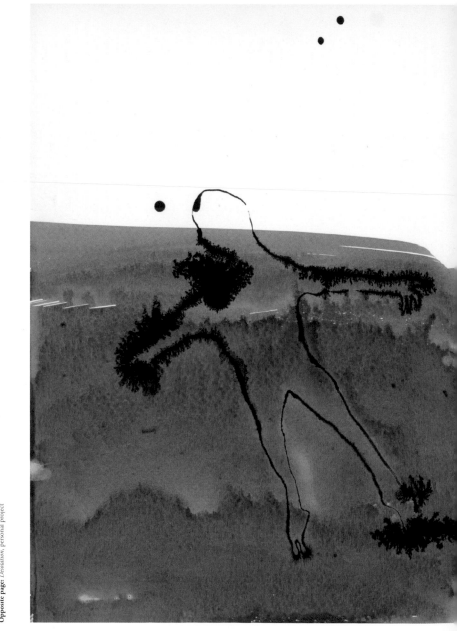

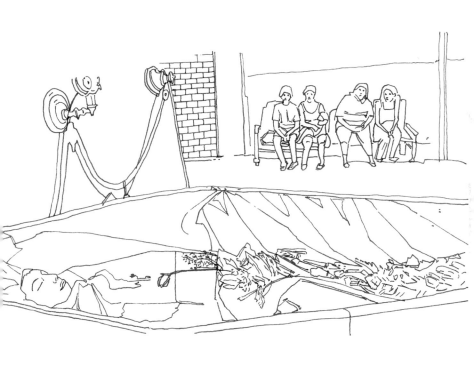

Peter Arkle

Eight confessions by Peter Arkle

'1. Sometimes I just draw something I want to draw and make it fit whatever project I am working on. 2. Sometimes I have an idea that's so simple or clever that it involves hardly any drawing. 3. Sometimes I have no idea so the simplest or cleverest thing is to do lots of drawing. 4. Sometimes I've written, "Imagine a better drawing of _____ here".

5. Sometimes I photograph myself and then trace from these photos and turn myself into a woman. 6. Sometimes I look for inspiration on Google. 7. Sometimes, on Google, I find something that isn't porn. 8. Sometimes I have an idea while talking to the person commissioning me and they like it and then I draw the idea, send it to them and they say, "Thank you very much".'

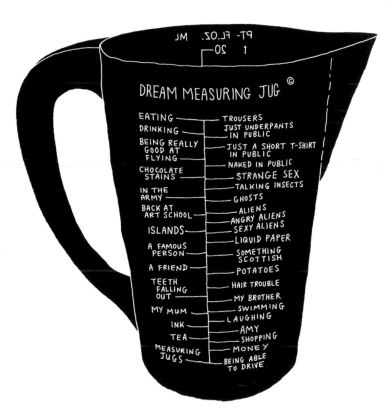

PT· FL.OZ. ML
20 1

DREAM MEASURING JUG ©

EATING — TROUSERS
DRINKING — JUST UNDERPANTS IN PUBLIC
BEING REALLY GOOD AT FLYING — JUST A SHORT T-SHIRT IN PUBLIC
— NAKED IN PUBLIC
CHOCOLATE STAINS — STRANGE SEX
— TALKING INSECTS
IN THE ARMY — GHOSTS
BACK AT ART SCHOOL — ALIENS
— ANGRY ALIENS
ISLANDS — SEXY ALIENS
— LIQUID PAPER
A FAMOUS PERSON — SOMETHING SCOTTISH
A FRIEND — POTATOES
TEETH FALLING OUT — HAIR TROUBLE
— MY BROTHER
— SWIMMING
MY MUM — LAUGHING
INK — AMY
TEA — SHOPPING
MEASURING JUGS — MONEY
— BEING ABLE TO DRIVE

14

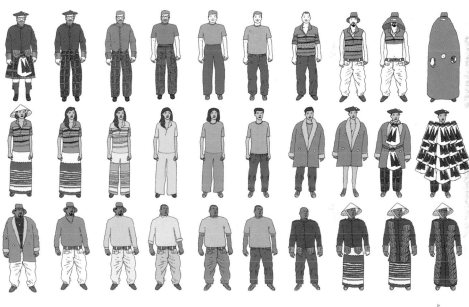

Opposite page: *Dream measuring jug*, produced for *Peter Arkle News* issue number 50.
This page: *Fashion evolution*, produced for the annual report of the Fashion Institute of Technology (New York)

This page: *Bored painter,* produced for *Peer Ankle News* issue number 52
Opposite page: *Signs from the streets of Park Slope, Brooklyn,* produced for
Peer Ankle News issue number 45

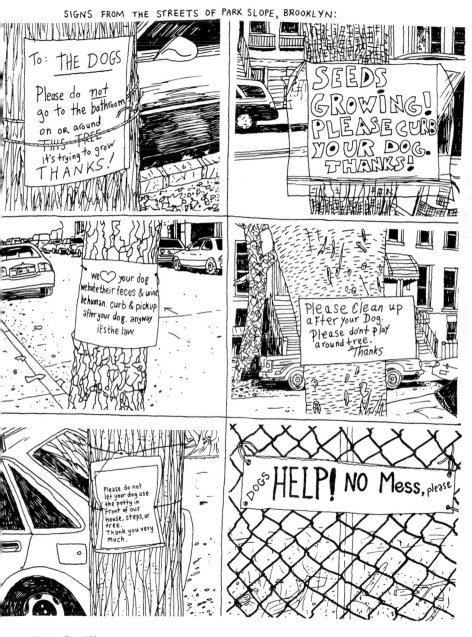

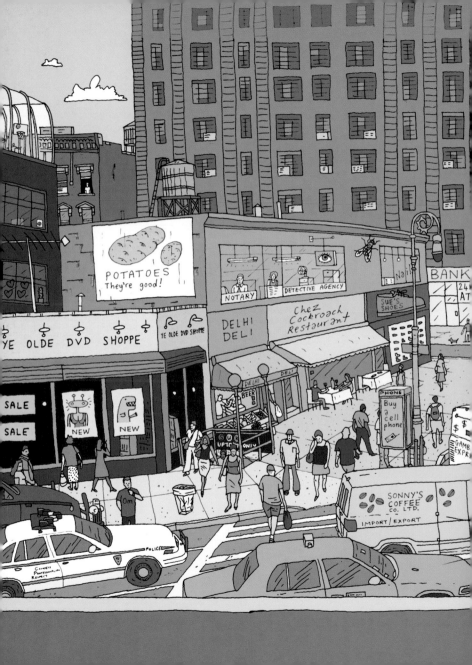

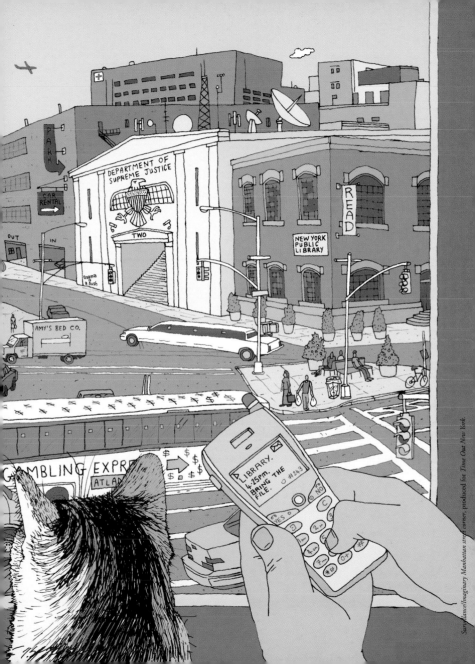

Nicholas Blechman_

'I draw because of deadlines; because I love filling up sketchbooks with pen and ink drawings; because drawing helps me filter my surroundings; because I am more articulate with images than words; because drawing is playful; because I can express my political anger; because people have been drawing for thousands of years and so it must be an animal instinct; because my father is a cartoonist; because my uncle is an illustrator; because my grandfather was an artist; because drawing helps defer the cost of living and pay the bills; because dinner tastes better after a hard day drawing; and because drawing makes me happy (but writing about it makes me miserable).'

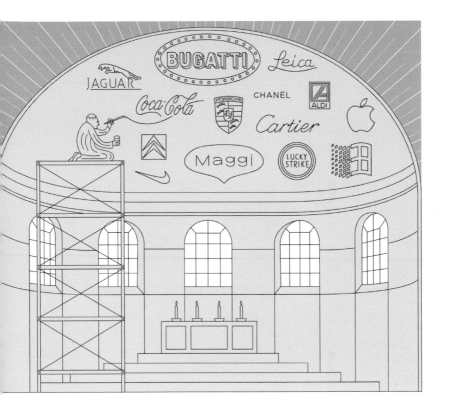

Opposite page, and small image on this page: *How to Hate America*, produced for *SZ-Magazine*

This page, top: *The Cult of Brands*, produced for *Wirtschafts Woche*

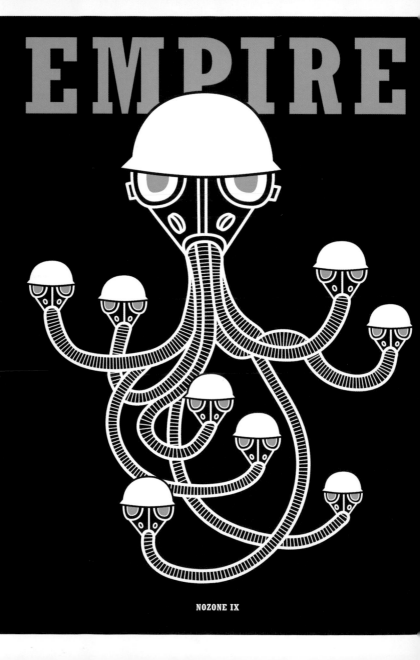

EMPIRE

NOZONE IX

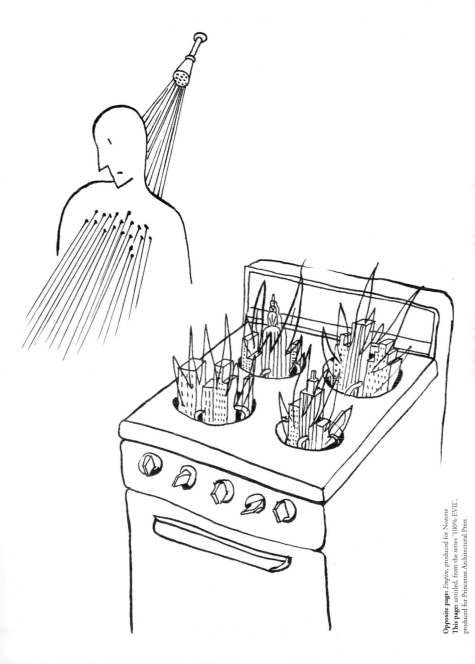

Opposite page: *Empire*, produced for Nozone
This page: untitled, from the series '100% EVIL',
produced for Princeton Architectural Press

Kerrie Jane Stritton____

"I spend most of my life in a perpetual dream world, my mind drifting through landscapes where narratives start to form. Some spill out as a single image where, within an empty landscape, I imagine what strange incident has taken place. Others are ongoing, larger and can only be expressed within a series of images. I am always inspired by places I visit, but Britain has often been my main inspiration. There are so many different exciting environments but sadly people feel they have

to go backpacking up a mountain to experience a "real view", disregarding the everyday. Me? I can almost have an orgasm over an industrial wasteland."

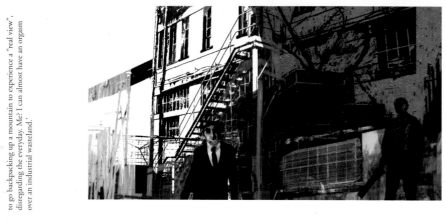

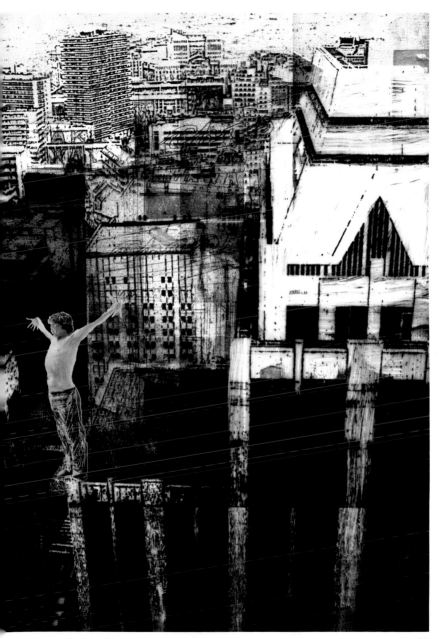

Opposite page: *Untitled*, from the graphic novel *Crowded Skies*
This page: *Leap of faith*, from the same novel

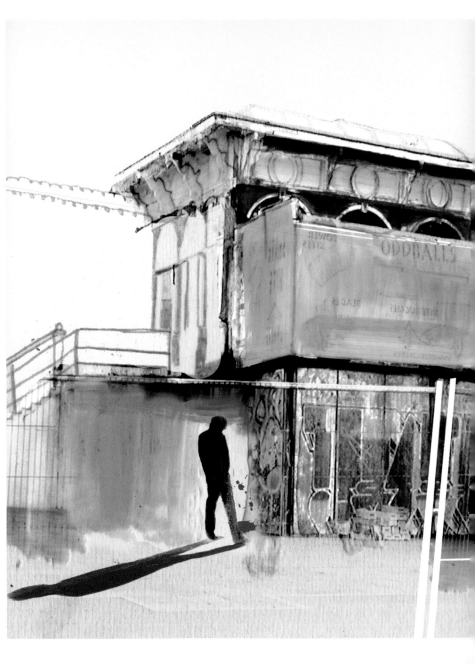

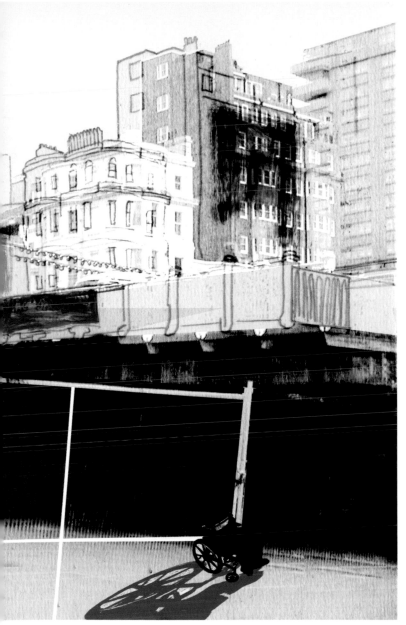

Brighton Piss, personal project

Boris Hoppek___ 'I never really talk about my work. Art historians and journalists can talk or write about my work but I'd much rather spend my time creating art. As well as illustrating, I paint and sculpt. My early influences were my parents, Keith Haring and friends but, at the moment, my work is largely inspired by my life and the world around me. At the moment it is Barcelona, a break and friends. Barcelona has such a rich painting history and an equally exciting contemporary scene. It is maybe the last city in the first world with a huge street-art culture. Street art (graffiti) is respected by the people and the police and even the city council has noted the difference between painting on the street and simply making marks (or tags). In short, in Barcelona graffiti is tolerated and on Sunday afternoons you will see me and my friends painting in the centre of the city.'

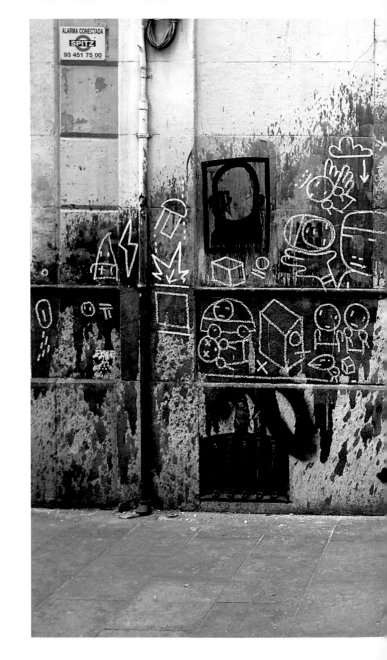

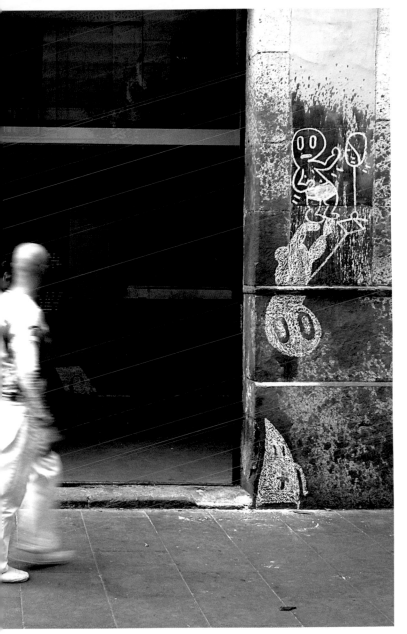

Chalk drawing over black printing ink splattered by a very angry street artist with Japanese friend in Barcelona, produced for this book

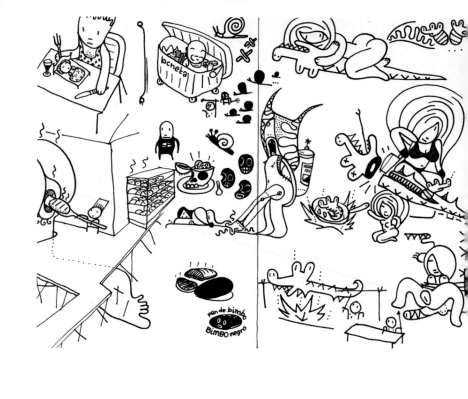

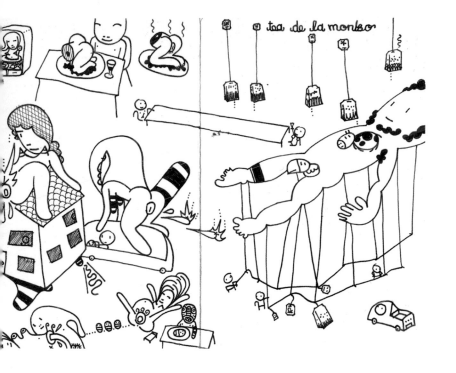

Sushi, junkfood, babybread, friedmonkle, flamedpussysauce with tea, taken from pre-exhibition idea-sketchbook for Moda Fad, Barcelona, 2004

Billie Jean____

Yuko Kanazawa in conversation with Billie Jean.
YK: Isn't Billie Jean a girl's name? BJ: Yes it is. Billie Jean is a *nom de plume*. My real name is Samantha. *YK: Isn't Samantha also a girl's name?* BJ: Yes. In fact, it's an incredibly pink and frilly girl's name. But Samantha is also a very popular and rather butch boy's name in SriLanka. *YK: Back to the old school and most of your other work is inspired by things you love and hate. What do you love and hate this week?* BJ: I love the NHS, Leytonstone,

telephone doodles, mittens and in-between meal snacks. I hate those men who hang miniature boxing gloves from their car rear-view mirrors, musical ringtones, coffee in styrofoam cups and litterbugs. *YK: Interesting. I think you need to see a therapist. I can recommend someone.*

Opposite page: *Hair Peace No. 6*, produced for the 'Grow your hair for peace' series

This page: *Village People*, produced for *Graphic Magazine* issue No. 5

Back to the old school, produced for the 'Ballpoint' exhibition at the Pentagram Gallery, 2004, celebrating 50 years of the Parker Jotter pen

Gary Taxali____

'I draw pictures for a living. "Drawing is good fun", that's what I keep telling myself but I worry when I think about what I would do if my career dries up. I'm lucky that people pay me for my work but it often scares me as I have no other skills. I used to work for the post office on the loading docks. It was hard work and I hated finding rodents hiding in the mailbags. My supervisor would look at me in disgust because I was a slow worker. I also sold coupon books door-to-door – many were

slammed in my face. I also drew caricatures in an amusement park, another hellish job and one that scarred me for life. It's probably why I don't draw portraits. A seagull once made a deposit right smack on the page while I was drawing, no lie. It's probably the most honest criticism I have ever received.'

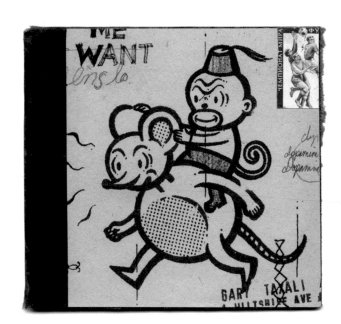

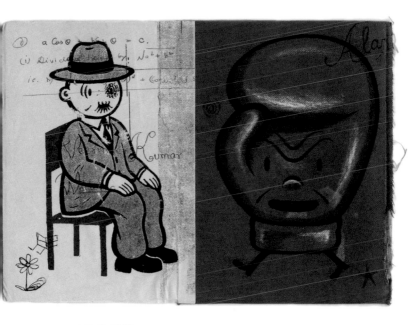

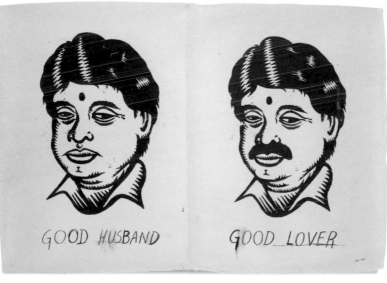

GOOD HUSBAND

GOOD LOVER

Opposite page: *Junkie Rat*, produced for *Time* magazine
This page, top: *Black Eye*, produced for *Men's Health* magazine
This page, bottom: *Good Husband/Good Lover*, personal project

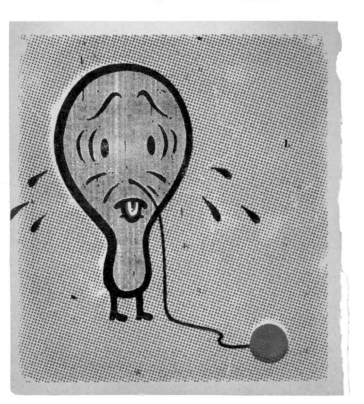

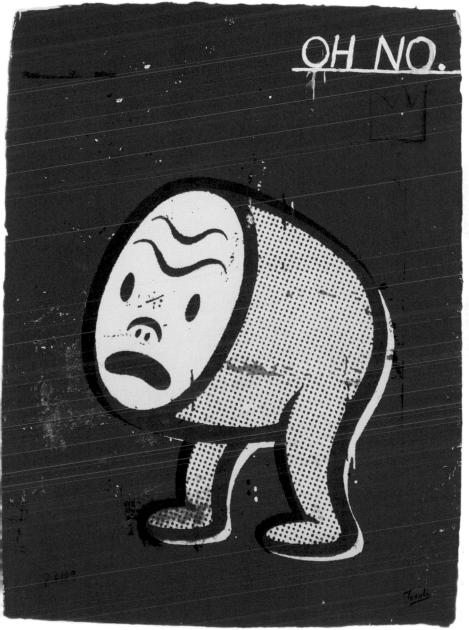

Eduardo Recife___

'I have been drawing since I was little. At school I had notebooks filled with drawings instead of notes. I used to tattoo my buddies with a black ink pen. I used to draw on any kind of surface when I was bored... I believe it's what I do best. It's also the best way for me to communicate things I can't find words for... It's therapy, it's a hobby, it's a job and it's what makes me happy.'

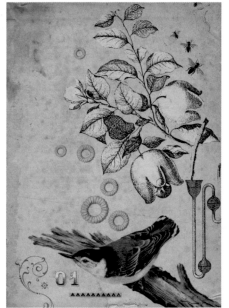

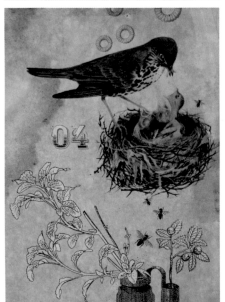

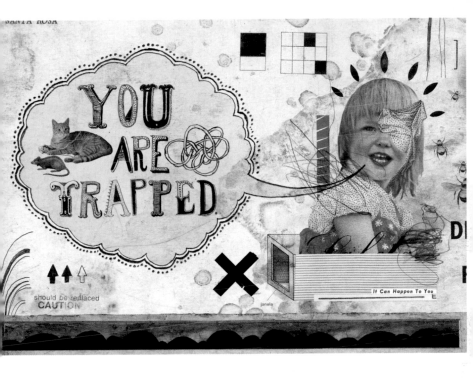

Opposite page, both images: *Birds, flies and plastic flowers*, illustrations for *Brazil Inspired*, published by Die Gestalten Verlag, Germany
This page: *You are Trapped*, personal project

e seu amor?

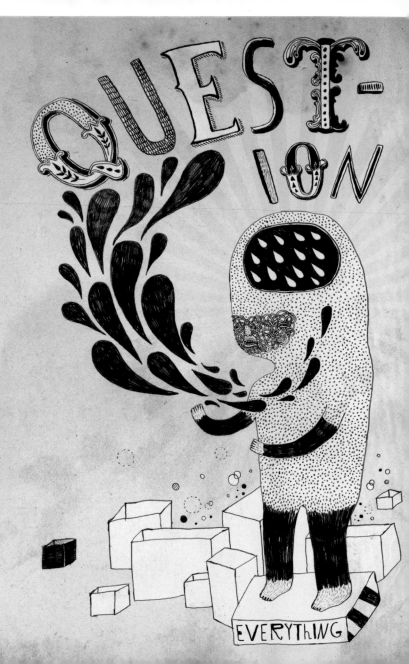

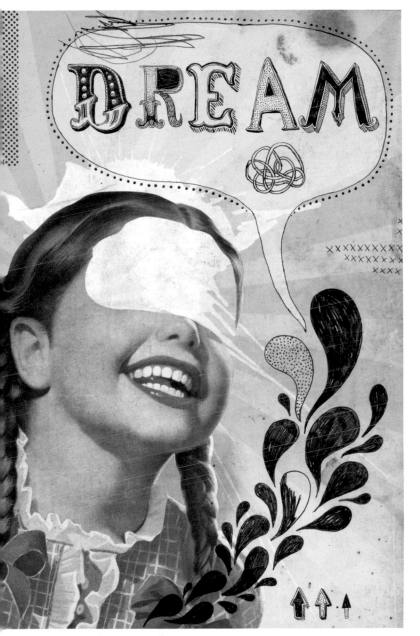

Opposite page: *Question Everything*, personal project
This page: *Dream*, personal project

David Foldvari___ 'I was born in Budapest in 1973. For now, I live in England. I am represented by Big Active. Today's date is the 29th of September 2005. Tomorrow morning, I'm going to get into a black Mercedes Benz and drive into Europe. I'm not really sure where I'm going, how long I'm going for or what I'm doing once I get there. I am taking everything I need with me and will carry on working and surviving as normal. If you want to see what I got up to, look at my journal at http://davidfoldvari.blogspot.com.'

Opposite page: *Muslim*, personal work, part of the 'rightwrong' series
This page: *Angel*, personal work, part of the 'rightwrong' series

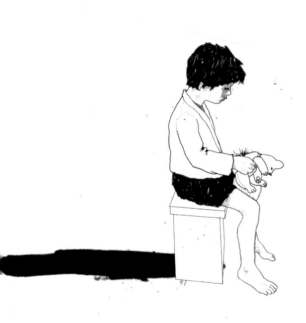

NU -SA INTAMPLAT NIMIC.

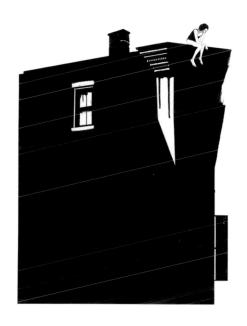

Opposite page: *Boy*, personal work, part of the 'rightwrong' series
This page: *Rooftop*, personal work, part of the 'rightwrong' series

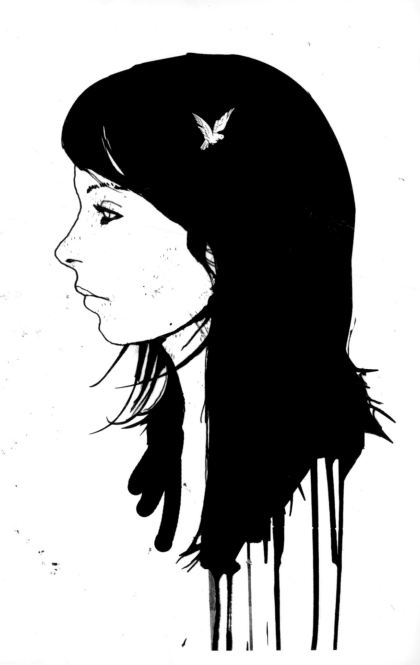

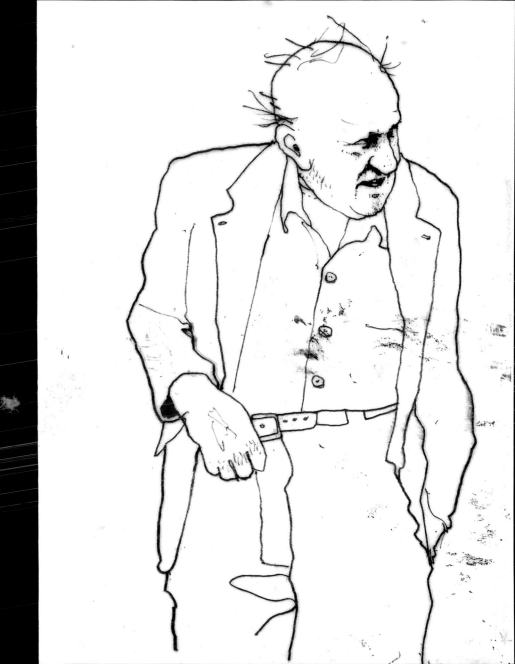

Rinzen___ 'RINZEN were grown in a petri dish containing a hybrid medium of Pantone ink, linseed oil and Perspex glue. The resultant five-headed protean life form astonished observers by landing paid employment despite attending art college. After prolonged exposure to vectors, provoking what scientists vaguely refer to as a "bad trip", they stole an idea from the Surrealists and rode it over the fence to freedom. Those that strain their hearing at a certain time of day can still hear the group's communal whoops and yodels echo down through forests and ranges of their own devising, out and to the west towards the very picture of a technicolour storytelling sunset.'

22

The Fox Project (*The Dryads*), artwork for wallpaper in The Dryads room at Hotel Fox, Copenhagen

This page: The Fox Project (*The Dryads*), artwork for wallpaper in The Dryads room at Hotel Fox, Copenhagen
Opposite page, top: The Fox Project (*Sleep Seasons*) for Hotel Fox, Copenhagen. Acrylic paint on walls, hand-dyed and appliquéd bedspread and curtains. Photography copyright Diephotodesigner.de
Opposite page, bottom: Animals for the credit cards of Switzerland's Corner Bank

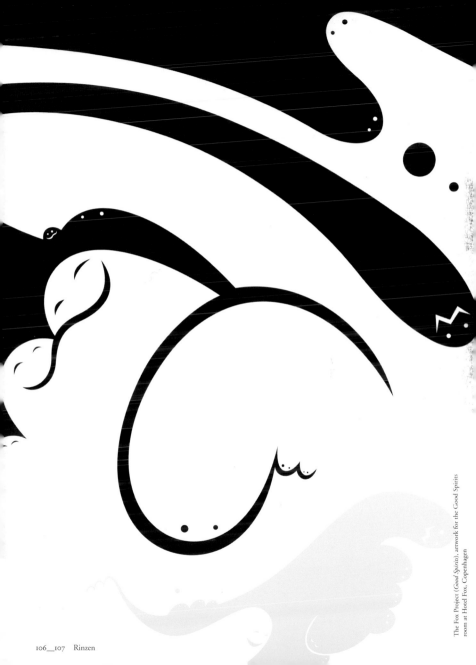

The Fox Project (*Good Spirits*), artwork for the Good Spirits room at Hotel Fox, Copenhagen

Marion Deuchars___

'I have a memory from a young age of having two strong interests: art and athletics. They seemed incongruous, but were they? One minute I was slogging my guts out on a racetrack running long distance and the next I was quietly colouring something in laboriously for hours, barely moving. The thing that made me train and race despite every muscle in my body aching was the attempt to get better (I averaged third place) and I think I start every artwork with the same anticipation and excitement that it could potentially be a great piece of work. It never is, but sometimes it gets close and that seems to be enough to make me try again next time. If I ever lose that feeling then I will start to worry – it's nervous energy and fear that motivates me.'

Opposite page: cover for Jeanette Winterson's *Weight*, part of Canongate's *Myths* series

This page: cover for Fourth Estate catalogue

SOUP

Three spreads from Jamie Oliver's book *Jamie's Dinners*, Penguin Books

Illustrations for the Planeta Annual Report, Spain

Debbie de Coo

Eenvoud

'Ik zie veel drukte om me heen.
Veel gehaast, mensen
die van alles willen en moeten
en de lat ontzettend hoog leggen.
Ik zorg er bewust voor dat mijn
leventje overzichtelijk en niet
te complex wordt. Onthaasten
is een modewoord dat bij mij zijn
juiste betekenis vindt.

Na het werk vind je me vaak samen met mijn
maatje en man Richard in de keuken. Daar staan we,
met een wijntje in de hand, heerlijk te kletsen over
de dag en de dingen die ons interesseren. Ik hecht
veel waarde aan eten en de sociale functie ervan.
Al jaren ben ik idolaat van Italië en La dolce vita.
We hebben vrienden in Bergamo waar ik eigenlijk ieder
jaar een paar weken naar toe moet. De taal, die
rollende r, de handgebaren, emoties en openheid.
Ik kan er geen genoeg van krijgen.

Net als het landschap dat zo heerlijk glooit
en je een sprookjesachtig gevoel geeft. Ook
daar vind ik een soort eenvoud in het leven.

Aandacht voor de familie, respect voor de
natuur en de ongekende passie voor koken en het
leven. Wij zijn hier zo van de regeltjes en de
structuur. Daar is het meer improviseren en iets
positiefs doen met de situatie, in plaats van
deze te veranderen. Italianen zijn zo heerlijk
makkelijk en bijna altijd gezellig. Hoewel mijn
leven redelijk gestructureerd is, ben ik ook
makkelijk en flexibel.

Mijn deur en ijskast staan altijd voor iedereen
open. Ik hoop dat dit zo blijft. Ik ben
nu al een paar maanden in verwachting.
Een magisch en heel intens gevoel. Ik heb al een
ontzettende band met die kleine. Een klein mensje
in je buik doet mooie dingen met je. Hoewel ik de
babykamer al bijna klaar heb, neem ik bewuster rust
en tijd voor mezelf. Heerlijk met een boek 's avonds
op de bank met Richard naast me.

Simpel maar mooi geluk waar
ik veel kracht en energie uit haal.'

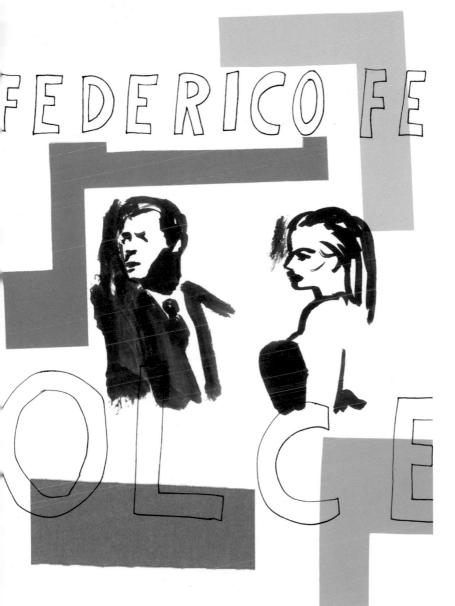

Jaarverslag 2003 Politie Gooi en Vechtstreek, a spread from the Dutch Police Annual Report

Isabel Bostwick___ 'I used to draw very slowly when I was only wee. But then I got less wee and everything seemed a little bit more worrisome so I speeded up. After that I stopped caring so I slowed down again. Now I draw REALLY slowly, in bed. But I always meet my deadlines because I don't have anything else to do, and I really like doing it. My boyfriend brings me angel cakes on a little plate, and he hoovers up the crumbs where they land and get stuck in the crease of my belly. He hoovers them up with his beardy face. I can't imagine a job I'd enjoy better.'

038

Opposite page: *Le chat*, from the artist's book *Leaves from an artistic bush*
This page: *Dorothy and Toto*, winner of second prize in the Folio Society Illustration Competition

Aude Van Ryn___

'Beautiful light and colours, the diversity of people, a walk through the countryside or through cities, a good play, watching films, observing my children, foreign cultures, listening to music, rhythms, silences ... I absorb all kinds of images from daily life and store them as visual notes in my mind. I also keep a lot of sketches and scribbles for future reference or to spark off a project; they can express my state of mind; colours change as well. Sometimes the topics are close to

what's happening in my life ... I enjoy every stage of the image-making process. Subjects don't really matter as long as I'm not given too many directives. The work does not evolve in a linear way – there is a recycling process that is pretty much constant but it can take months to see the progression. What makes me feel good is looking at the work as I always think that things continue to move on and can be pushed further. There's plenty still to learn.'

YOUR FAMILY
NSPCC

Newsletter
JUNE 04

ORKS
ORANGE

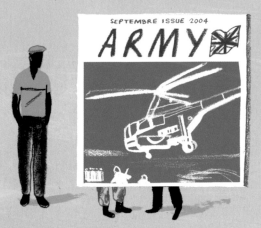

SEPTEMBRE ISSUE 2004
ARMY

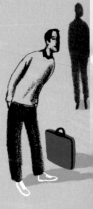

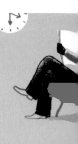

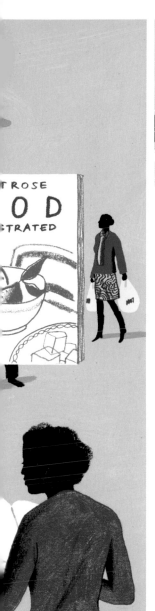

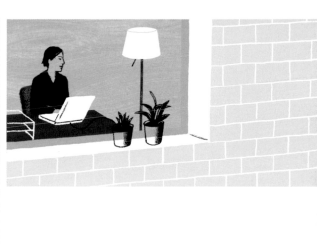

Opposite page: produced for the Association of Press Agencies to illustrate the article 'Magazines do the business' about customer magazines and their essential role in the marketing mix

This page: illustration for the article in *You* magazine, 'Body Blues'

Agnès Decourchelle___

'As far as I can remember, I've always tried to draw what surrounds me. My eyes would register reality, my mind would filter it and my hand would translate it. I see my illustrations as my interpretation of the reality, like moments captured in my mind: moments that seem a bit strange to me, or people's faces or daily subjects. My drawings are like a collection of frames taken from a movie that I made up in my mind.

My sketchbooks are my faithful companions on my travels. These sketches are an inspiration for my other works. They form my diary of moments and reflections. Some people don't think my approach to drawing and colour is very logical but to me it's like embroidery: I start one side of the subject to slowly give it a recognizable shape.'

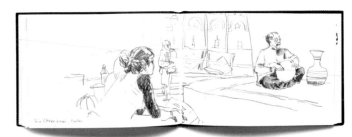

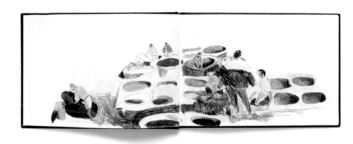

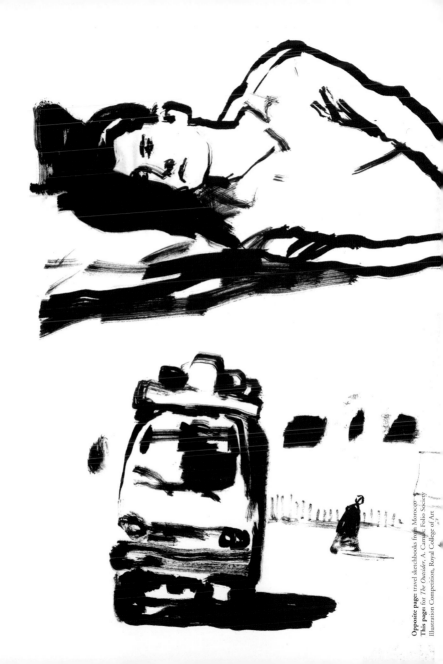

Opposite page: travel sketchbooks from Morocco. **This page** for *The Outsider*, A. Camus; Folio Society Illustration Competition, Royal College of Art

A CONTRE - COURANT

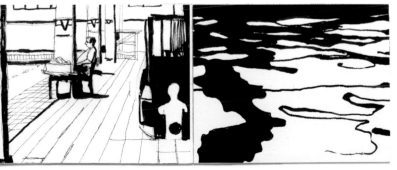

Opposite page: illustration for the book *Mon Pays C'est Paris*
This page top: *Pas of talent*, illustration for *The World of Interiors*
This page bottom: *A Contre Courant*, book project on Parisian swimming pools

Astrid Chesney___

'I have drawn since I was a child and remember feeling most comfortable and contented when drawing. I have always liked to tell stories with pictures. I remember being small and feeling completely enveloped by the pictures in storybooks where I would lose myself and invent my own stories.

I like that what I create hasn't been created before. I depict two very different extremes in my drawing: one that is serious and thoughtful; the other spontaneous and ridiculous.

This is perhaps a response to how I view life and who I am. I enjoy the act of painting and drawing with tone and line. I love to tell a story, to develop characters and create an atmosphere where I invite the reader to share my other world. On the other hand, I've always liked creating spontaneous imaginary characters. I'm not sure where they come from, or who they are but they entertain and surprise me.'

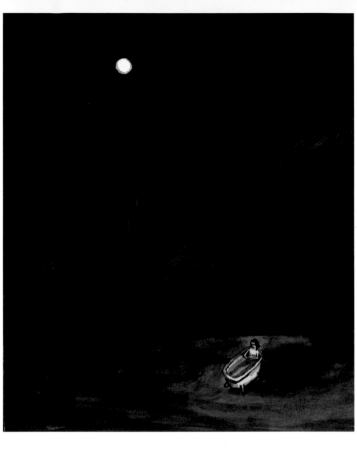

Opposite page: *Bath Under the Moon*, from the book *La Nuit*, personal project
This page: *Bill*, magazine illustration

Opposite page: *A Belly Full of Boys*, for a series on 'Snow White' images
This page: *Pot*, from the book *La Nuit*, personal project

Gina Triplett___

'I grew up in the country with a bunch of younger siblings. We did quite a bit of storytelling to entertain ourselves, and we'd draw pictures to go with them, so my interest in illustration kind of grew from this. What drives me now is the need to come up with new things to amuse myself. I look to nature, vintage textiles and old lettering amongst other things. A lot of patterns, animals and plants show up in my work, all of which I like to surround myself with, so my work is a good

account of how I see the world. The opportunity to show work in galleries is a refreshing move and energizes my illustration work. Marks, images and ideas that might not come out in the constraints of commissioned work can be developed when I have free reign. It comes full circle when I see elements in an illustration that originate from a painting done for a show. Each clearly informs the other and essentially helps me develop as an artist.'

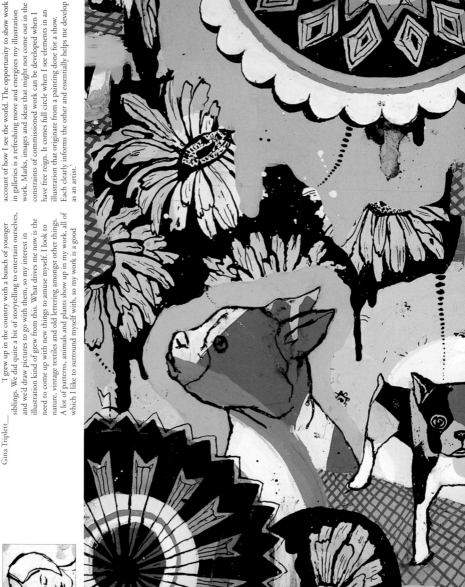

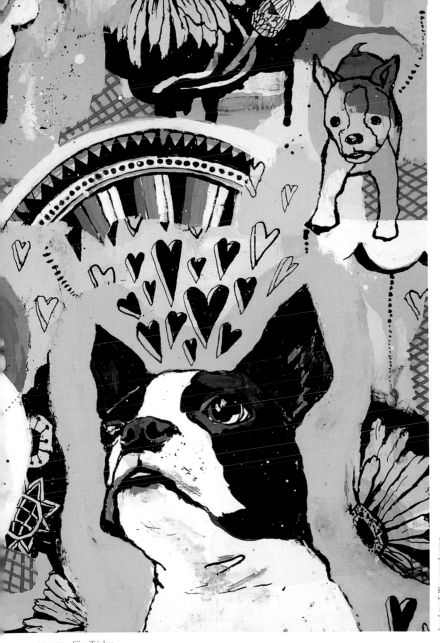

Love Letter To Wes, personal project

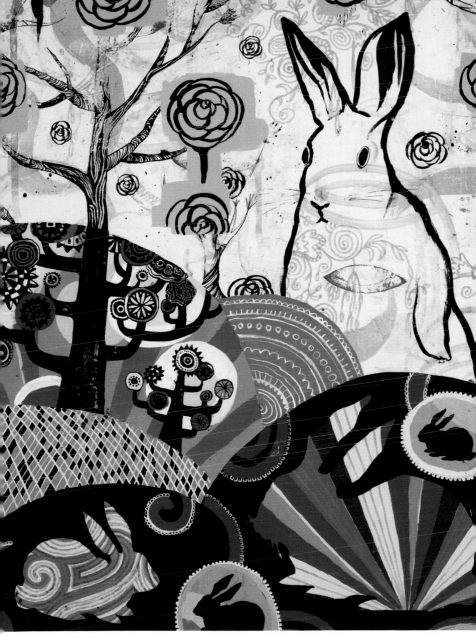

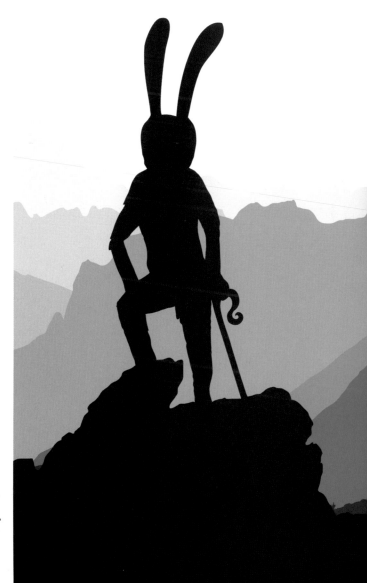

Airside____

'Storytelling is Airside's favourite pastime and illustration is a favourite way of making our worlds come to life. Hares climbing the Alps, pixel doctors with naughty nurses, a frog-headed boy running from his shadow and singing, break-dancing farmyard animals. With illustration there is no need for rationalization in these worlds.

We all come from very different backgrounds and training and coming together around the meeting room table to discuss a new project can be a very lively event to say the least. And sometimes we stare blankly at each other and agree to resume later in the day.

Airside has been around since 1998 and hopes to continue inventing implausible characters till we don't know our names and can't hold the pens.'

Wandering Rabbit, illustration for the annual of student
winners of the D&AD student awards 2004

Opposite page: *Battle Royale*, image created for the promotion of the Japanese film *Battle Royale*
This page: *Shopping trolley*, design for screenprints and T-shirts

Kam Tang__ 'I grew up working in my parents' catering business. Taking orders from thankless customers, I worked gruelling backbreaking hours well into the night and sacrificed weekends while my friends revelled, only to be rewarded with paltry wages. So when the chance came to escape the suffering I chose to design and illustrate. I couldn't have got it more wrong – but at least I enjoy what I do now.'

Two Culture Clash, produced for the inner bag wraparound for the LP by Two Culture Clash

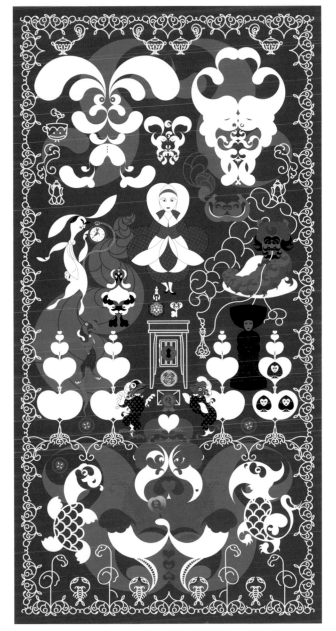

Opposite page left: *Sheep in Bonnet*
Opposite page right: *Garden of Live Flowers*
This page: *Alice*

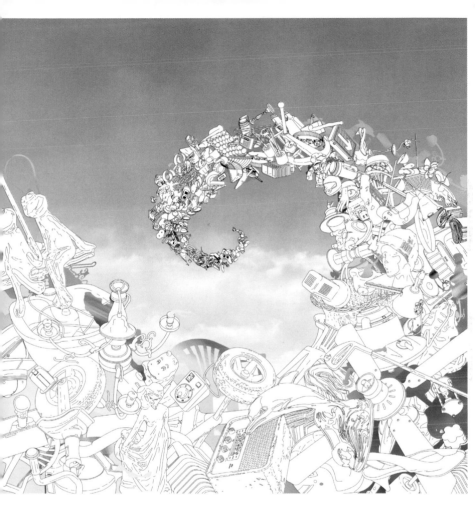

QuickHoney — 'QuickHoney: What is QuickHoney?
Special forces forced me.
My honey gave it to them on arrival.
None of this is generic, any stupid frog smells.
My hairy balloon is angry, the plane landed on her table.
QuickHoney time.
I'm sensual, sexy, a little shy.
Born on a mountain, raised in a cave.

Just like the Pottery Barn... You break it you own it.
Honey what you do and do who you love.
QuickHoney time.
I'm evil. She wanted to know more.
I just love to meet new people.
Sounds great. But are you being realistic?
Nice mix of quick girlishness and tomboy interests.
QuickHoney time.'

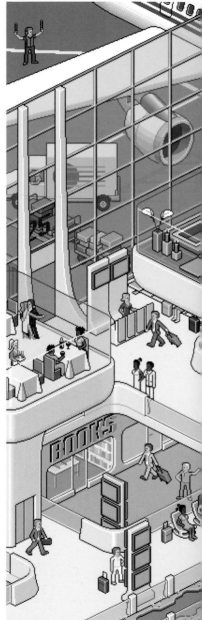

Modern Airport, produced for *Outside* magazine

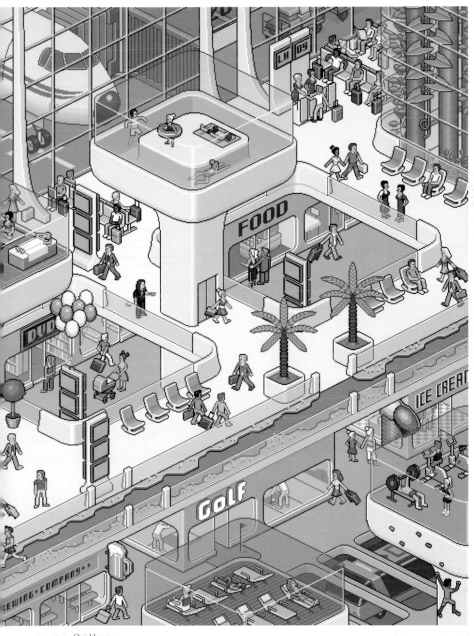

Lucy Vigrass

'My colour palette is very important to me. Apart from a brief foray into pastels at around 13 and an attempt to be tasteful at 18, I have always been a fan of bright colours. I keep a file that's comprised of my preferred colour palette and use it as my rule of thumb, although subject matter dictates to a degree. These colours, usually against black or grey, make an image that's definitively me. Using flat colour and simple shapes makes screen-printing an ideal medium. Although deadlines dictate I use the computer more than I used to, I try printing as often as possible. It's good to get dirty and inky. But it's a constant frustration that I can't produce a print without a bit of unwanted grub. In my personal work I like playing with shapes and patterns to make abstract pictures but I also look forward to getting new editorial briefs. I always experience a sense of relief when I've come up with a solution; I treat it like a puzzle.'

Opposite page: *The Group Who Couldn't Say 01*
This page: *The Group Who Couldn't Say 02*
Both produced for the '930 Sq Ft of Peepshow' exhibition

Left to right: *The Group Who Couldn't Say 03*; *The Group Who Couldn't Say 04*; *The Group Who Couldn't Say 05*; all produced for the '930 Sq Ft of Peepshow' exhibition

Clarissa Tossin___

'I went to design school but somehow, because people seem to feel attracted by the images I make, I also ended up being an illustrator. Indeed, I used to draw fantastic mushrooms and some other doodles when I was a child. Even though my mom always said I would work with "something visual" she didn't miss my "art" when, at the tender age of ten, I decided to put my artistic ambitions aside.

It was a while before I realized that the computer would enable me to do my "visual thing" and before long it became a full-time concern for me. So with two cats and a boyfriend to feed on a regular basis, needless to say I need to work, but I also love to work.'

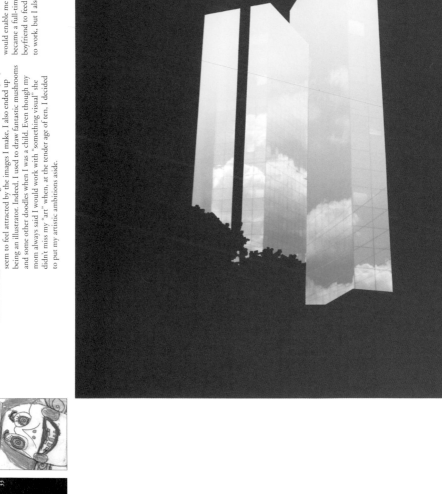

'Sky_Boxes' is a series of digital collage illustrations, inspired by the sky's reflection on glass-mirrored skyscrapers.
Opposite page: *Sky_Boxes 02* (grey background)
This page: *Sky_Boxes 01* (yellow background)

Opposite page: *Sky_Boxes*
This page: *Sky_Boxes 07 (*

Guillaume Wolf_

'As a kid I was the underdog with all kinds of problems – drawing quickly became a refuge in which to express my creativity. Later, when I tried to enter the French art schools, I didn't pass the exams so I'm almost entirely self-taught. I read a lot and found some good souls to point me in the right direction. To this day I'm still very curious – I'm hard-wired for curiosity. I'm very interested in the relationship I develop with clients. Most of them have a vision, expressed in words, and my job is to translate it visually – I'm a visual-translator. I'm also a problem-solver. The process of freelancing is very mercenary: there's always a line-up of freelancers for one job. The client has to choose only one – it's leap of faith. I get a buzz from this competition, but ultimately, if I do work on something and the client is happy with the result, that's my reward. That's why I only select jobs where I know I can deliver big-time.'

Al Heighton___

'A colleague asked "Why illustration? Why do you do it?" I said, "because in my teens I failed science and maths and I was a geek and it was the only way to impress a girl. Besides, I love drawing and it doesn't involve wearing a suit and tie." My old man said to me the other day, "son, you're getting good at colouring inside the lines but what goes on in that mind of yours?" A student e-mailed me the other day and asked me "what's your favourite piece of work?" My answer to that was

"the next piece, which I'll attempt after I've had a cup of coffee, which will be informed by that film I watched the other day that made me laugh or that snippet of dialogue I overheard from two chaps laying tarmac in the north of England, dialogue about the merits of a slave bangle and a hug and a kiss at the end of each night from a good woman."'

Opposite page: *Cronies*, a personal project produced as a postcard for self promotion

This page: *Carrot Man*, personal project

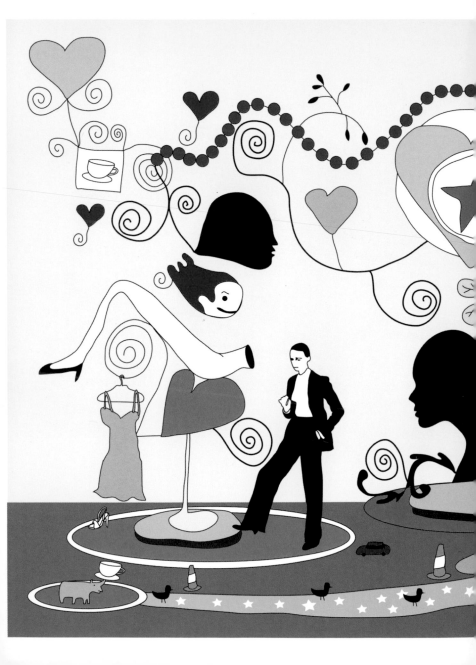

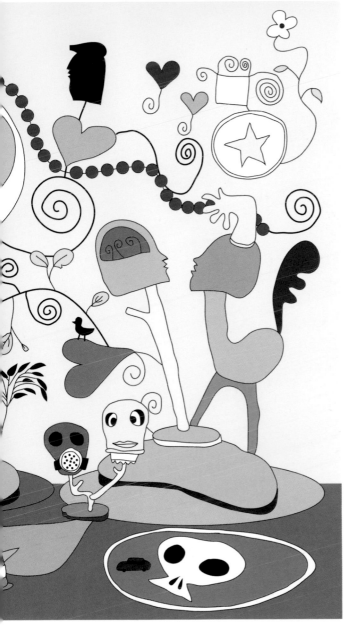

Close Too, a personal project

Deanne Cheuk___

'I didn't even know what graphic design was until it was time to make my selections for university and my art teacher suggested it to me and described it as "designing toothpaste boxes". Luckily, that really excited me! Luckier still, I've never had to design a toothpaste box! Illustration was something I fell into after I moved to New York from Australia and I didn't have a scanner, so I taught myself to trace photos from the Internet on my computer in Illustrator to get the images I needed for things I was designing. Next thing I knew, I was getting all these commissions for portraits and landscapes and soon it became too physically overwhelming to keep working that much on just the computer. Now it's a combination of hand and computer so I never really know what the final image is going to look like until it's done.'

36

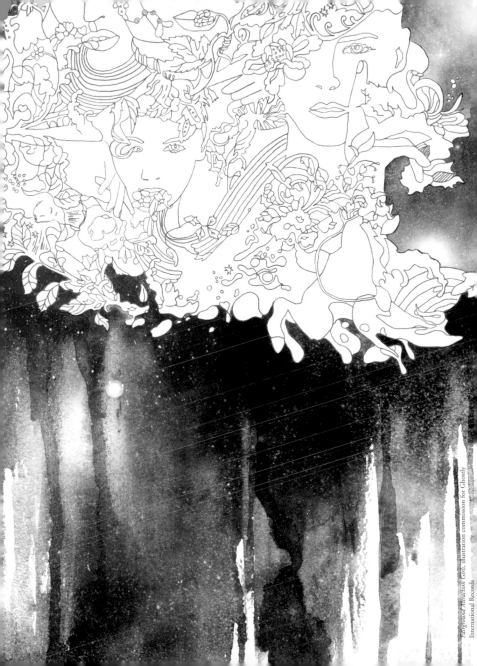

Fairground Attraction Girls, illustration commission for Ghostly International Records

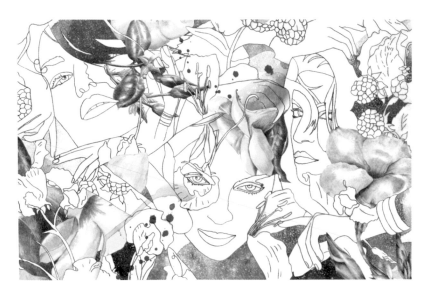

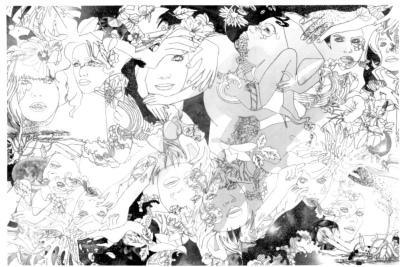

Opposite page: illustration commissions for *Nippon Vogue*
This page: *Mushrouge Girl 01*, personal project

Izzie Klingels___

'Predictably, I've always liked to draw but I've had my ups and downs with it. I spent my teenage Saturdays at life drawing classes. I used to work as a life model too, which I thought made me very bohemian. At art college in the early 1990s, I realized that drawing was deeply unfashionable and quickly ditched it in favour of installations, performances and video. After college, I devoted a few happy years to the lost art of film projection with my friend Spencer Bewley, under the

moniker of Lazy Eye. We made visuals for bands and clubs, touring the world and not getting much sleep. After the millennium it seemed like time to try something different so I decided to give drawing another go. I like being an illustrator because you can do it on your own and all you really need is a pen and paper. It's solitary but it's not lonely.'

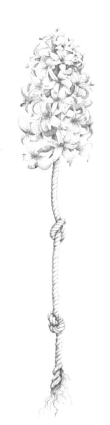

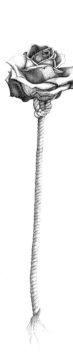

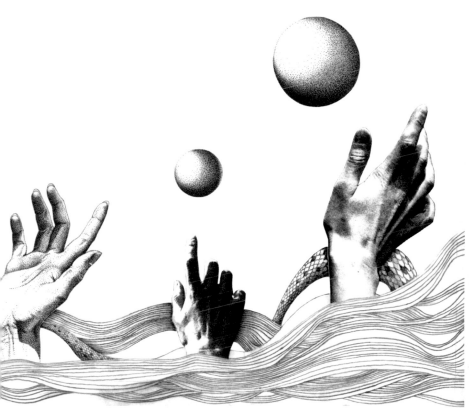

Opposite page: illustration for *The Wind Tells The Tale of Valdemar Daae*, Hans Christian Anderson
This page: record sleeve for Apartment single *Patience is Proving*

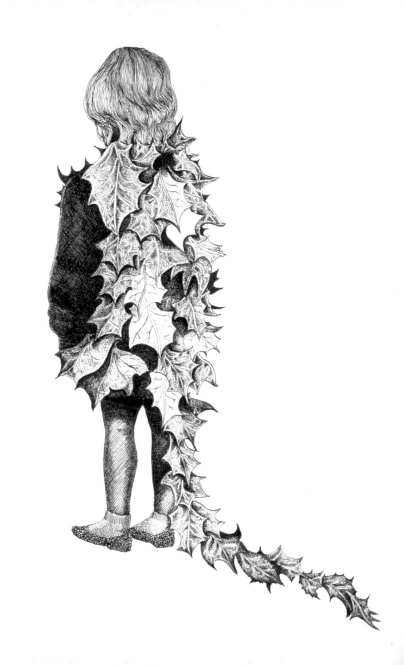

This page: record sleeve for Garden EP *An Introduction to …*
Opposite page: imaginary poster for Glastonbury, commissioned
by *Nylon* magazine

Alan Baker___ '... photos, paint, people, stories, charades, power-
tools, sand-paper, drills, ply, running, waiting, ships, peach
trees, planes, traffic lights, tits like coconuts, red herrings,
abandoned furniture, stubs, hookers, trophies, TV, landscape,
north Yorkshire, New York, the everyday, the lead in my pencil,
road markings, tower blocks, pubs, horses, heroes...'

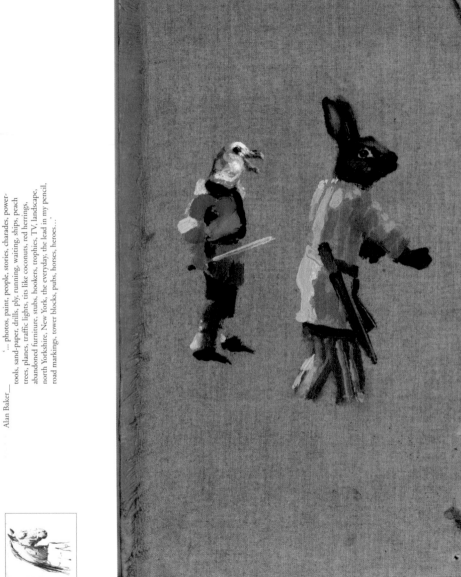

Animal Heads, for 'Bookwise', *Sunday Times Magazine*

Out of town edit suite, illustration for *Televisual* magazine

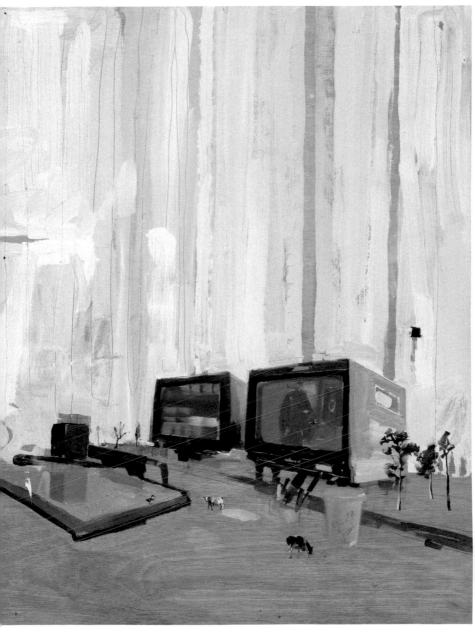

Alan Baker

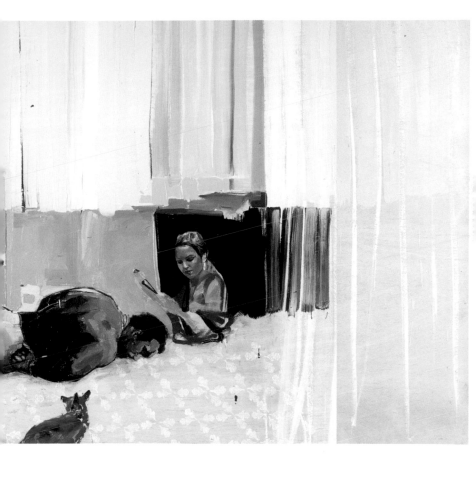

Samson and Delilah, illustration for *Lion's Honey* by David Grossman, Canongate Books

Michael Gillette___ 'At around 12 I discovered the thrill of drawing, that little sugar rush of creating something seemingly from nothing. It really hooked me and I've been chasing that feeling ever since. When it eludes me I feel shiftless and it'll make me stay home on sunny Saturdays and try to... draw it out. Most of my skills are learned by trial and error, but I try to avoid getting too caught up in the technical side of things. If it doesn't serve the idea then its flavour doesn't last too long.'

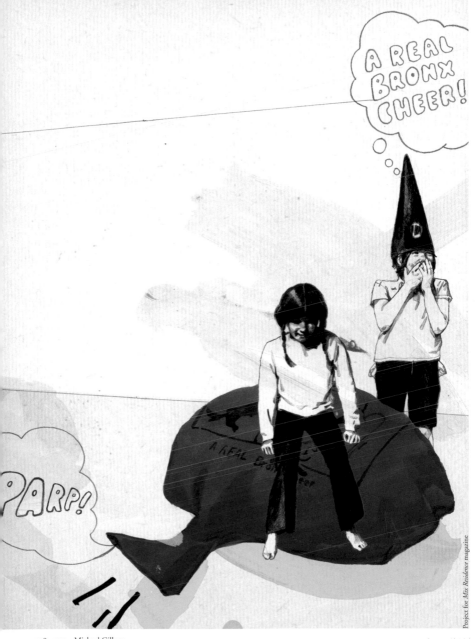

Project for Mix Residence magazine

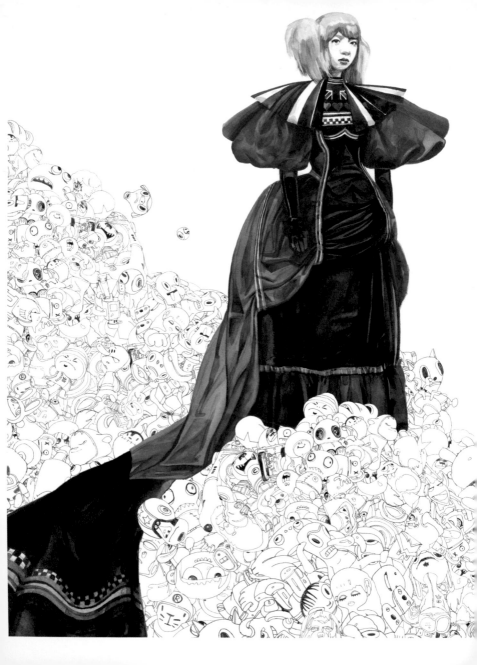

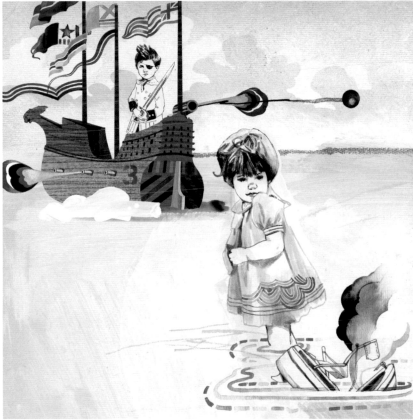

Opposite page: *Landfill of the rising sun*, personal project
This page: *Why so cruel?*, personal project

Reggie Pedro___

'I grew up in East London. My early interests were cars and I used to build go-carts out of pram wheels and wood. I became so obsessed with building these things that my mum began to wonder if there was something wrong with me. Me and my friends also used to build hideouts from wood on rubbish tips, a place we could call our own, away from the adult world. So I've always done things with my hands, including drawing. Without sounding boastful I remember being the only kid in primary school to draw people from a frontal view with feet pointing forwards rather than pointing in opposite directions. Painting came later, I was never fond of paint and considered it too messy to control or do anything proper with. I developed an appreciation for what can be achieved with paint after visiting an art gallery (the Tate) for the first time, aged 17. It was from around here that I decided to pursue ART, for better or for worse.'

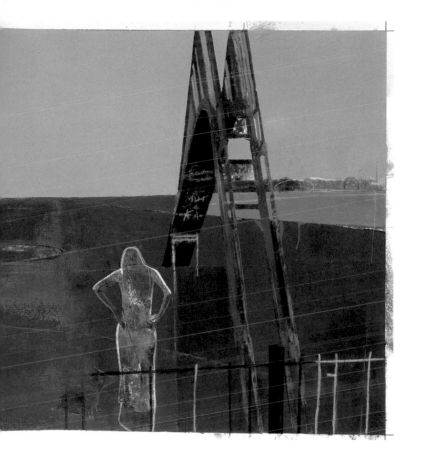

Artwork for the Gomez single *Bring it on*

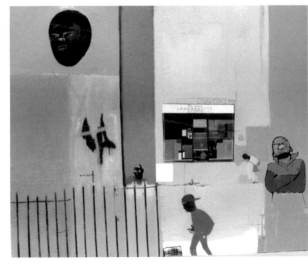

fire

LOV

Opposite page, top: artwork for the Gomez single *Rhythm & blues alibi*
Opposite page, bottom: *Smiley*, personal work
This page: *Firelove*, personal work

Jesper Waldersten___

'I don't think too much about what I'm doing, I just have to do it. For me music has always been the inspiration and relation – or the lack of it – between people, the core in my work. I've been drawing and painting all my life but I tried to run away from it for a fairly long time. After a couple of years in the advertising business as Art Director at Hall & Cederquist YR in Stockholm, my illustrations finally caught me and screamed at me to jump off the advertising train. I started to

draw pictures with the mouse; I had to simplify it all and get rid of the details that were too hard to draw. The drawings were called "Pictures you don't want your kids to bring to family therapy" and bam boom! Finally I was home. I'm very analogue but ironically enough it was the computer that helped me find the channels I needed to express myself. Like black and white. Letting you decide what colours it should be.'

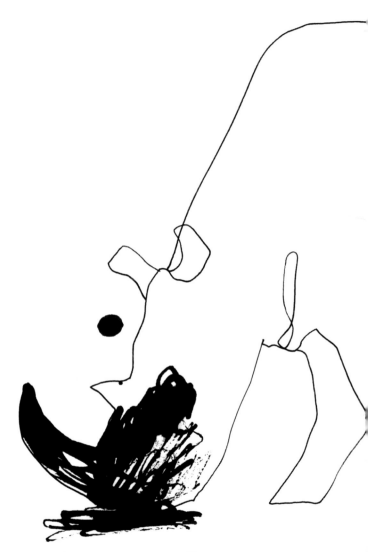

Rhino eating ink

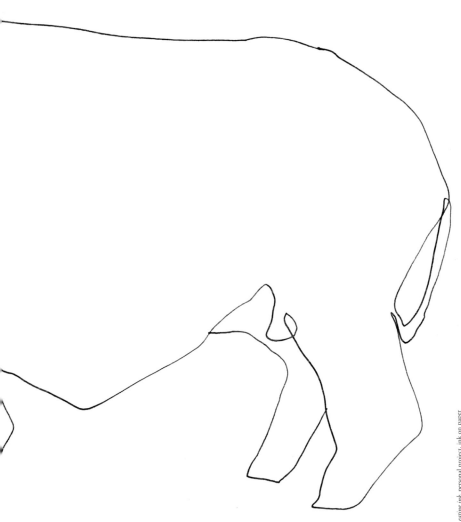

This page: *Rhino eating ink*, personal project, ink on paper
Following page: textile pattern, personal project, ink on paper

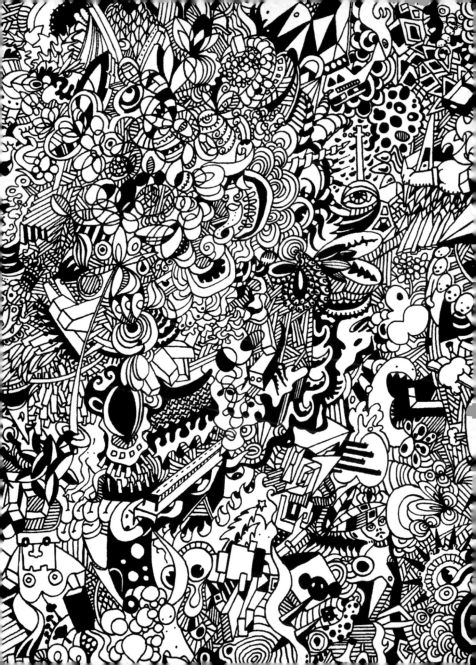

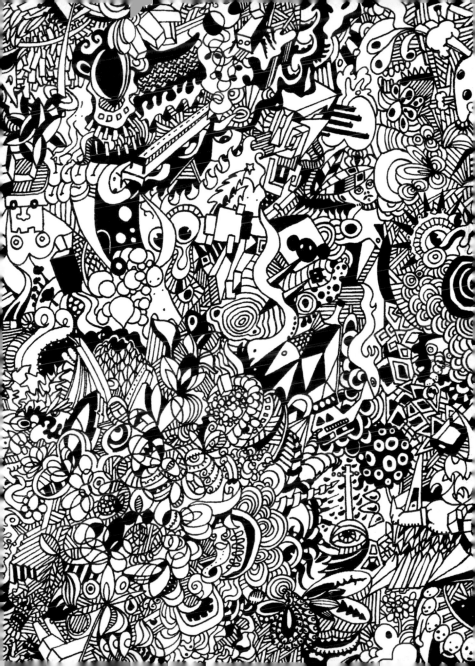

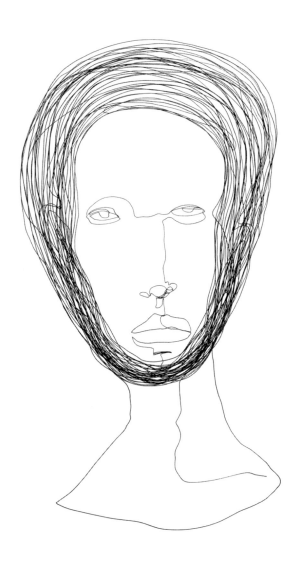

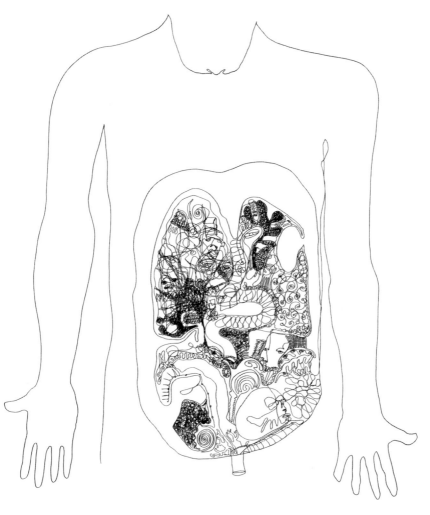

Opposite page: *Isolation*, produced for the *One black line* exhibition at Färgfabriken in Stockholm. Drawn with one line
This page: *Telephone anatomy scribble* produced for the *One black line* exhibition at Färgfabriken in Stockholm. Drawn with one line

Lizzie Finn_____

'I remember thinking "this is what I want to do!" after the brilliant art teachers I had at Islington Sixth Form College had made me do loads of life drawing and taken me to see a big Pop Art show at the Royal Academy. At the time I was studying maths and computer science as well but dropped them both in order to do full-time art and design.

Later, I studied graphic design at Central Saint Martins where I started seeing the many links between computers, textiles and graphics, one being the similarity in the construction of an image made from bitmaps and that of an image made from tapestry stitches. One of the things I've always found interesting is taking elements from their accepted context and bringing them into another, therefore changing their message. I do this regardless of what medium or context I'm working in.'

Opposite page and this page, top row: selection from a series of 18 photographs of three large-scale embroidered fabric panels made for the book *Where is Silas?* and for an exhibition of the same name in Parco Gallery, Tokyo

This page, bottom row: images made for Vitra Home catalogue *Select and Arrange* 2005, constructed using Vitra's own fabric

Ceri Amphlett___

'Some reasons why I think I'm an illustrator: it's my calling; pure enjoyment; the variety of work; I can create my own working environment and surround myself with things I find inspiring and comforting and create mess and clutter. I can listen to music all day.

What I enjoy about being an illustrator: getting absorbed in the working process; the variety of subject matter; short deadlines; the feeling of completion and moving on to new projects; being able to listen to music while working; working with different people; the opportunity to develop creatively.

I'm mostly interested in creating character and depicting or inventing personality. To me drawing is about being able to add another dimension, making stuff up and creating new worlds. As a form of escapism I enjoy inventing strange characters and immersing myself in imaginary scenarios and personas.'

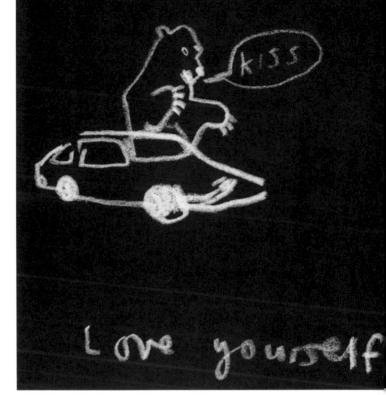

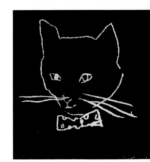

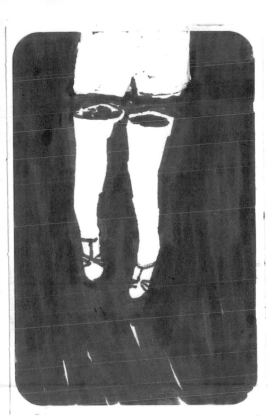

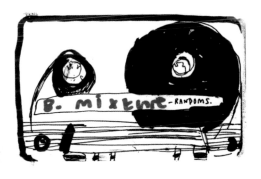

Opposite page, top: *Love yourself*
Opposite page, bottom: *Songs for people and cats*
This page, top: *Nice legs*
This page, bottom: *Randoms mix*

Ian Golds
+ bream 31692
at Pagham

Adrian Farley
+ 3lb 14oz bream

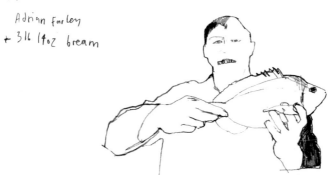

Mark Jakins
with a good bream.

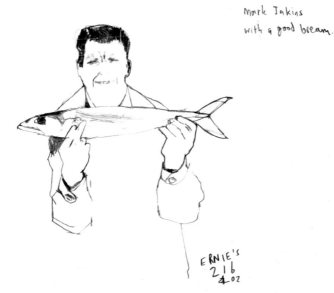

ERNIE'S
2lb
4 02

Opposite page, bottom: *It's not a laughing matter*
Other images: illustrations from the 'Men with fish' series

Antoine et Manuel_

'Our story could start the day our mothers gave birth to us. Antoine in a haute bourgeoisie family and Manuel in a dustbin. Our childhoods were as you can imagine, the first child raised by the best nurses and professors, the other struggling for life, sometimes at the edge of the law. You can picture us escaping our opposite yet alienating realities by drawing, making our dream worlds come paper-and-pencils true. Our story could also start the day we met, at school, in our late teens. Our aims were different at this point, sexual attraction made us get closer. In a novel, you'd probably prefer the love story. And this story may be the truest one actually.'

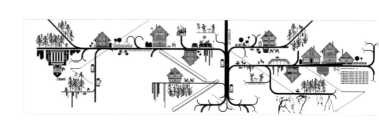

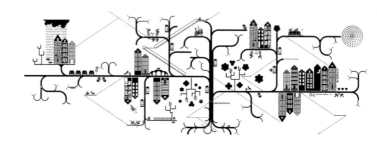

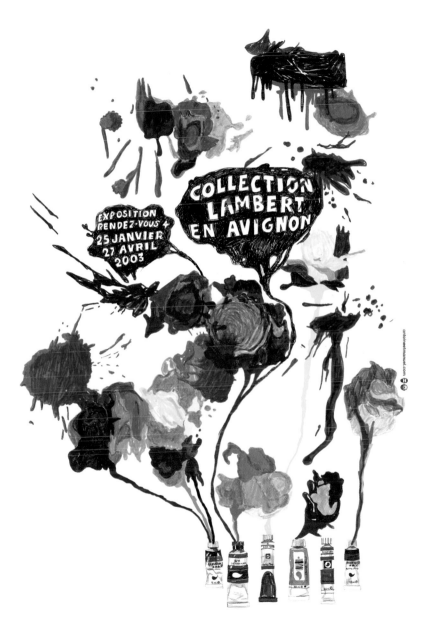

COLLECTION LAMBERT EN AVIGNON

EXPOSITION RENDEZ-VOUS 4
25 JANVIER
27 AVRIL
2003

antoineetmanuel.com

Opposite page: two murals for Maison Lafayette
This page: *Rendez-vous 4*, poster for the Collection Lambert, Avignon

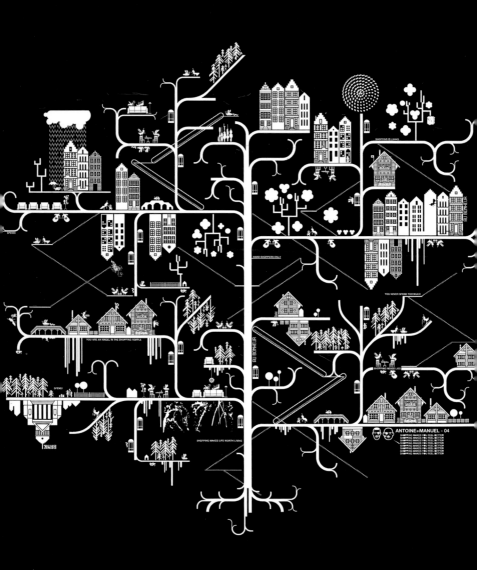

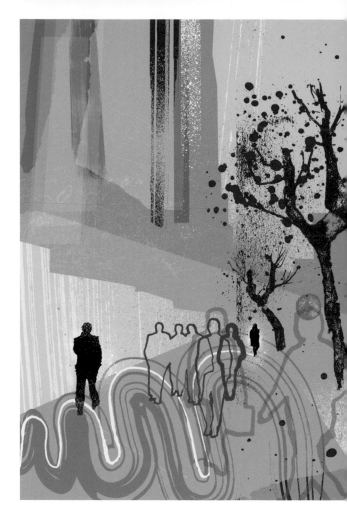

Shonagh Rae

'Ten things about me and drawing:
1: The first picture I remember drawing was in about 1972 in Mrs Damanski's class, of a pastel mermaid.
2: My favourite things to draw are hands and shoes.
3: I have always been more of a "drawer" than a painter.
4: The tools I use are dried-up brushes, borrowed pens and Google.
5: I am right-handed.
6: I generally feel most productive at about 11am.
7: I wish I drew more and used a computer less.
8: My favourite drawings are usually by friends.
9: I have never thrown away a sketchbook.
10: I am inspired by deadlines and Presbyterian guilt.'

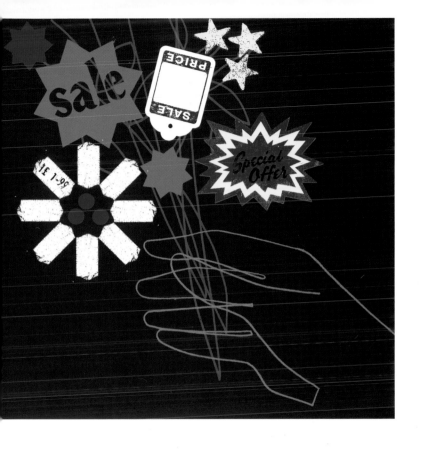

Opposite page: *Chance Traveller*, a short story by Haruki Murakami, published in *Harper's Magazine*

This page: *Shopping/Romance*, produced for *The Guardian*

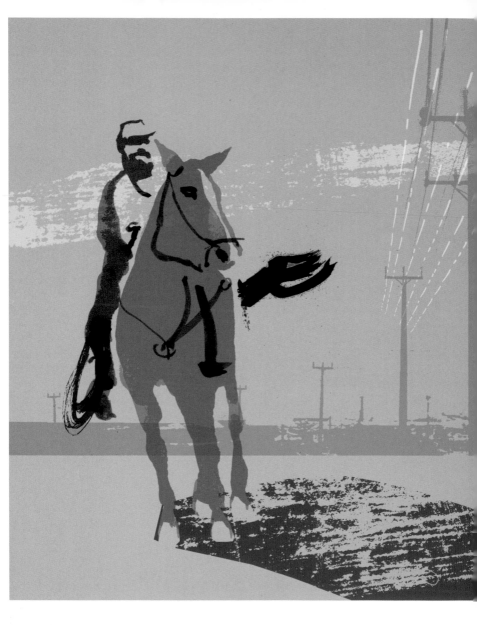

Opposite page: *Crimea*, produced for *Highlife* magazine
This page: *Kosel*, produced for *Highlife* magazine

Anthony Burrill___ 'I am interested in things. I like music, nature, living in the countryside. I like getting on trains and travelling to the city. I like quiet and I also like noise. The work I produce is an extension of me, a result of combinations of everything I've ever done, everybody I've met and everywhere I've been. The things I talk about in my work are ideas that float around in my head, mostly personal responses to being a human being living in the world trying to get on with other human beings.'

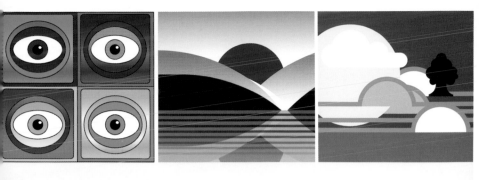

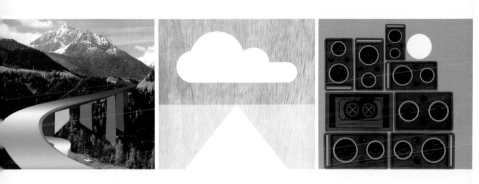

A selection of images made for a series of flyers
promoting 'Balearica', a monthly club night held at
The Social, London, featuring a different guest DJ and
live act each month. The images reflect the varied
music policy, from cavern dub to hi-gloss house music

Joe Magee___

'I remember my brother-in-law being flabbergasted when, having sat in his garden for an hour, I produced a colourful sketch of his house and gardens. "I didn't know you were a real artist," he remarked, suspiciously. I reminded him that I'd spent six years at art colleges and have drawn most days since I was eight. Most people only see my published work and virtually all the work I've had published in the past ten years has involved digitally manipulated images, normally photos.

Practically all those images have been resolved as a sketch beforehand. Recently, my commissioning editor at *The Guardian* suggested I start submitting the sketches as final artwork, which is food for thought...'

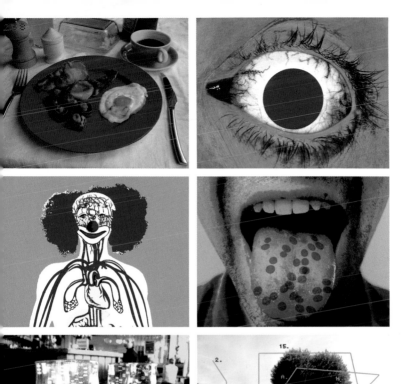

All images commissioned by *The Guardian* for the weekly science supplement *Life*

Opposite page, clockwise from top left: *Grape Power, Bacteria, Fat Pig, Puberty, Bio Bananas, Steward's Enquiry*

This page, clockwise from top left: *Remember to Eat, Diagnosis, Taste Buds, Wandering Eye, Hangover Gene, Laughter*

Benoit Jacques___ Born in Brussels in 1958. Spends the first half of
his life growing up in Brussels and not really finishing some
drawing and visual communication studies. Spends the second
half of his life in England where he gets married, becomes a
father and publishes many drawings in the press. Spends the
third half of his life in France trying hard to mix up the tracks,
publishing his own books and producing unrequested pictures.
Not yet sure what he plans to do with the fourth half of his life.

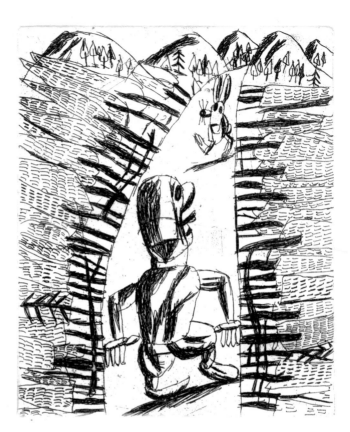

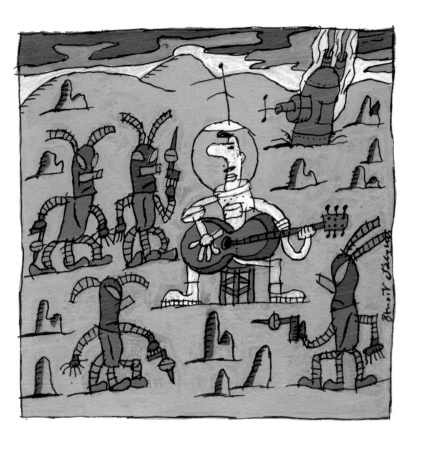

Opposite page: published in *Scandale au château suisse*, Benoit Jacques Books

This page: illustration published in *Magazine littéraire*

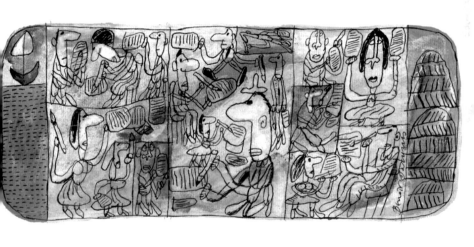

Opposite page: illustration published in *Salto Solo* (éditions de l'Inventaire, Paris 2001)

This page: illustration published in *Magazine littéraire*

Michael Comeau

'Self-expression is terrifying. Slowly, I learned that loneliness and alienation are even more frightening. I saw art as a beacon, bringing like-minded people into a community. I romanticized communities don't form as easily as I thought. I romanticized punk and underground comics, but now I see what co-opts and undermines them. Fascist capitalism tills fertile soil until it's barren. I enjoy the discipline that making art brings. When I think about what's tearing the world apart, I think of my fellow soldiers. It's them I fight for when I see no end to this war on imagination.

I like making posters, they serve a purpose, everybody gets to see them. They aren't precious but if someone wants to treat them special they can. I'll make more posters and publish more books – my own and other people's. I can't remember if I make art to insulate myself from the world or strike out against the mundane and the target-marketed – probably both.'

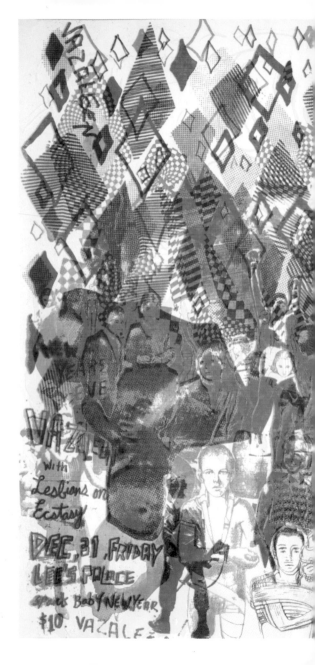

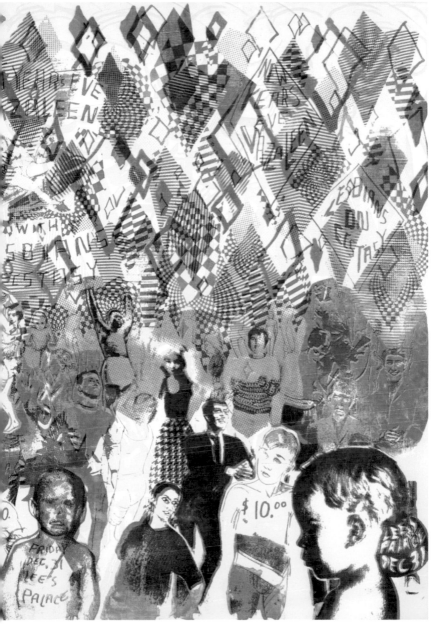

Opposite page: "Blue Lines" personal project
This page top: Illustration for The World of Interiors
This page bottom: "A Contre Courant"
book project on Parisian swimming pools

Maja Sten___ 'Playing means cleaning. As a child I didn't have many hobbies; I would mostly stay at home and fiddle about. One thing I loved was cleaning my grandmother's playhouse. My cousins and I spent hours dusting, polishing, sweeping, shaking, washing and scrubbing. Every summer it was the same procedure.

I clean automatically without thinking too much but with focus and joy. The music is important. It helps me find rhythm and feeling in the work. It makes me feel good.

No words are needed. I really enjoy cleaning on my own. Sometimes I find a thing I forgot existed, so I put it in the window so that I can see it again. Sometimes the hoover gets stuck behind the corner. I pull and pull and it just won't come closer until I realize I have to change the plug to a socket in a room closer to me.'

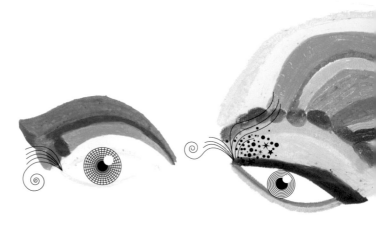

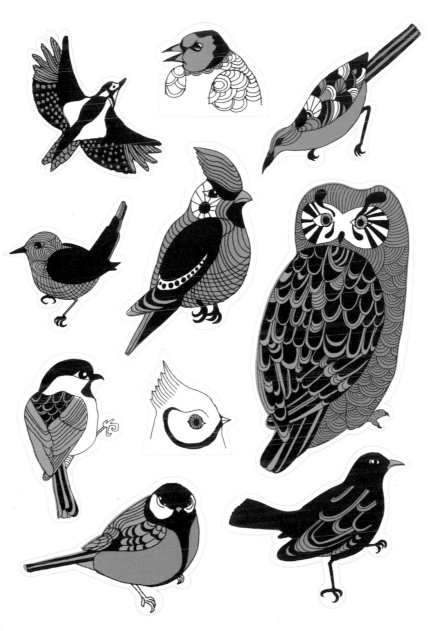

Opposite page: *Make-up*, illustration for *Sweden's leading newspaper*, Dagens Nyheter
This page: *Neighbours of the White Mountains*, personal project to announce launch of artist's website

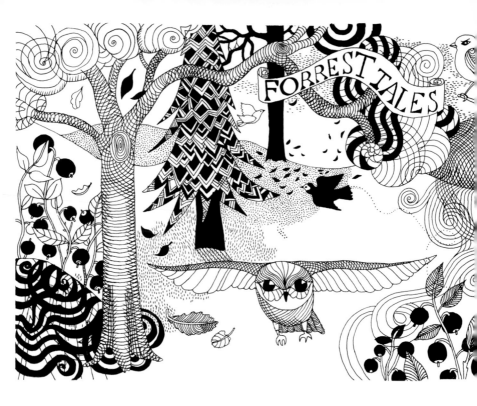

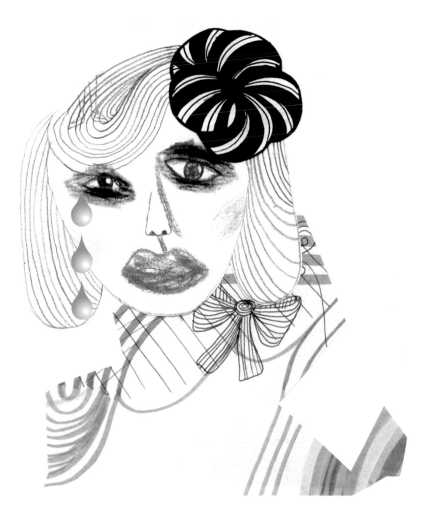

Opposite page: *Forest Tales*, invitation for a design exhibition in Tokyo
curated by Eva Schildt for Cibone
This page: *Make-up*, another illustration for *Dagens Nyheter*

Daisy Fletcher_ 'I've always loved drawing, reading and analyzing texts. Studying and working in illustration seemed a natural progression. I considered more "sensible" careers but knew my heart wouldn't be in it. Rather than being a reflection of my world, my work is more an act of escapology, where I disappear into a world of strange girls, with stranger hair, flowers and birds.

What inspires my work? Here are a few things ... the written word, strange stories, vulnerable characters, surreal twists, plants, flowers, wildlife, fashion photography, unusual compositions, and Japanese art/illustration. I enjoy the unusual range of commissions my work attracts, so I'd like to keep pushing my work and build on that level of interest.'

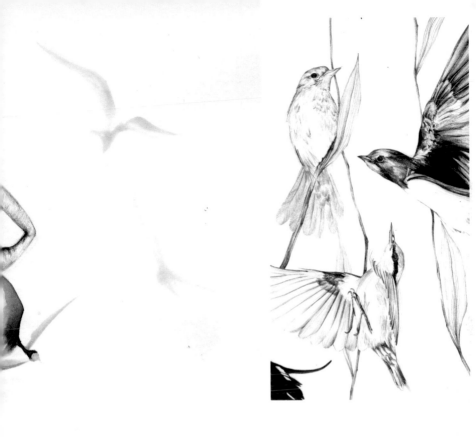

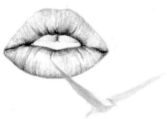

Opposite page: *Carangui,* commissioned by *Carlos* magazine
This page: personal project

Carolina Melis___

'I love scanning and I scan a lot. I'm not particularly good at photography and scanning has become a kind of a substitute. Over years of practice I've developed my own techniques and customized my scanner. I've collected a number of boxes, glass containers and paper with particular patterns, which I use as background or support for my scans.

My favourite scanning subjects are flowers and feathers. My animation *In Which a Butterfly Lands on a Zebra's*

Head has a sequence in which a surreal garden seems to bloom and die simultaneously. I did that by pressing flowers with a scanner, scanning them every several hours for a week and animating the sequence in reverse order. From pressed, dry and dark the flowers become fresh and bright. My second favourite subject is earrings – one pair in particular. They don't look very good on me but are amazing once scanned. This is also what I've learnt: that some objects are more scangenic than others.'

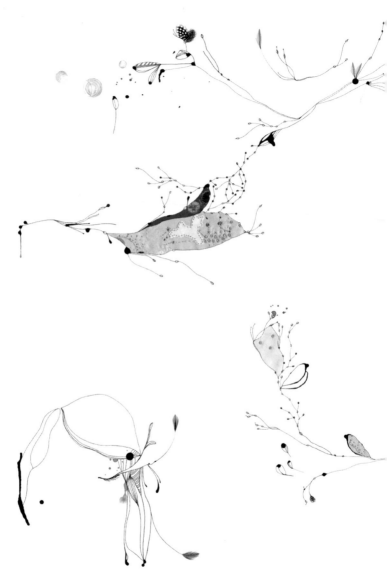

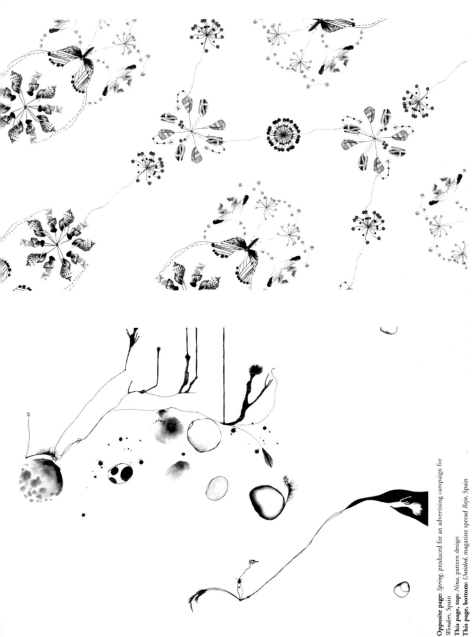

Opposite page: *Spring*, produced for an advertising campaign for *Wonders*, Spain
This page, top: *Nina*, pattern design
This page, bottom: *Untitled*, magazine spread *Rojo*, Spain

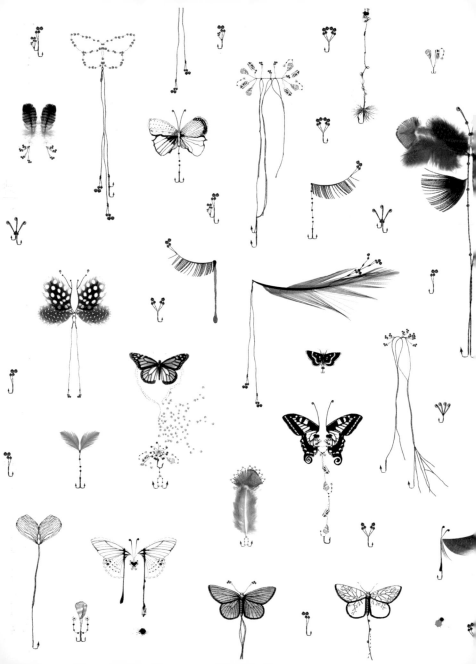

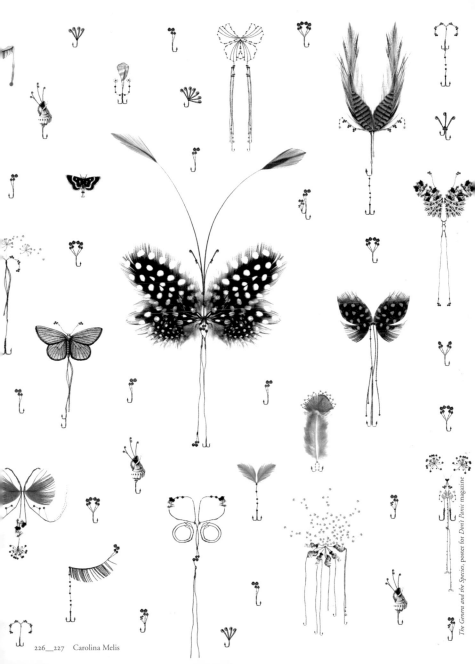

The Genera and the Species, poster for Don't Panic magazine

Nina Chakrabarti

'Essentially, my work is about getting black ink onto white paper. I strive to produce as beautiful a line as I can. I use a Rotring pen and paper stolen from the studio printer.

My urban Indian upbringing has informed and inspired a love for the decorative and ornamental. My need to embellish is almost a compulsion. Since arriving in the UK aged 12, allowed only one book from my childhood possessions, I've always unconsciously accumulated ephemera or "tat". I have acquired, amongst other things, buttons, mugs, tins, paper bags, shoes I no longer wear, money from far-away lands and dog-eared postcards. I increasingly draw these objects to exorcise my need to possess the real thing as though, once I've drawn them, I no longer need to hoard them in shoeboxes under the bed. The wallpaper I made, a life-size drawing of a kitchen wall, was a way of recording a certain time and place and keeping it to paste it up wherever I move to.'

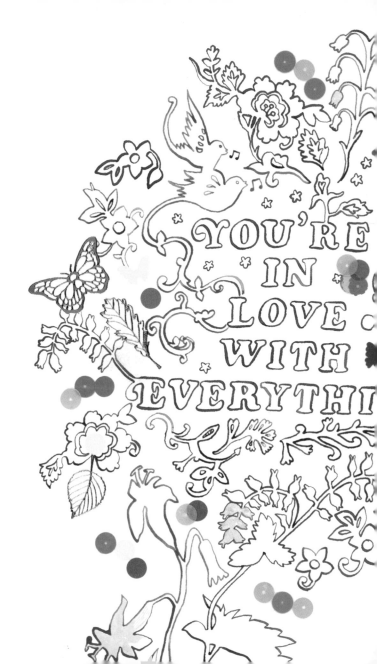

Opposite page: *You're in love with everything,* produced for Topshop instore advertising
This page: *Objects found in bag,* preparatory drawings for Red or Dead poster

This page: *Everything on my kitchen wall, detail from wallpaper*
Opposite page: *I see you everyday and I almost always take you for granted,*
self-initiated poster

MY FATHERS PLACE
0171 787 3255 EATERIES 386 Free House
MO-TOWN GOD'S TIME
HAND STATION RIES
CAR WASH NEWS AGENTS
NEWSPAPERS · TOBACCO · PHONE & TRAVEL CARDS
PEDRO'S L&D MOTORCYCLES
☎ SUPERTONE RECORDS
833-1246 Specialist in caribbean.african.u.s. 110 ACRE LANE
GOSPEL SW2 5RA
THE The Old Calcutta
RUSSELL TANDOORI RESTAURANT TAKE AWAY
HOTEL 157
COBBLERS NEST PET'S PANTRY
Park View Proprietor JE McLaren
DINOS HAIRDRESSER 020 7735 4104
SPIRITUALIST ☆ CHURCH PERDONI'S
film fare BLESSED William
071 274 2710
WEST · INDIAN · TAKE · AWAY HILL
Fish DUMPLING INN
& Chips CHINESE DUMPLING & NOODLE BAR 157
D. BESS. BAKERY
Essence of Beauty
Afro-Caribbean Salon
HAPPY SHOPPER HAPPY SHOPPER 329
BTB FOOD + WINE & NEWSAGENT
SEAGULL One Love Salon
LAUNDERETTE P
(BRIXTON LTD)
TEMPLE OF BACCHUS
CASH AND CARRY LADY WORLD
WINES SPIRITS BEERS CLOSED

230__231 Nina Chakrabarti

Andrew Rae_

'I grew up in Croydon and spent my adolescent years trying to get away. As a child I had a healthy interest in camouflage clothes and drawing war and soldiers, the kind where you make sound effects while you do them. I'd probably be in the army now if they recruited nine-year-olds. After that I started thinking I was an artist and tried to be all abstract, which was thoroughly unsatisfying, so I drew angry heads with vicious teeth for a while until I settled into my present way of working.

I guess I was very much your average Croydon-based kid, doodling pictures of war in my homework diary and using them to try and impress girls. I've been told my work has an underlying darkness and strangeness to it although I see it as keeping myself amused. My girlfriend's mum reckons I use my work to exorcise my demons. I don't know if that's true but I did stop killing people when I took up illustration... Makes you think, doesn't it?'

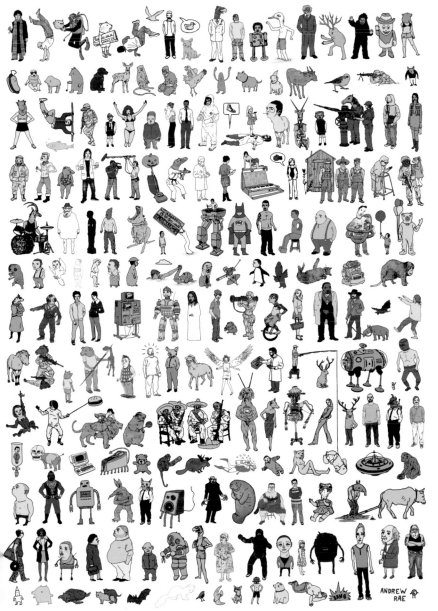

Opposite page: *Robot Friend*, exhibited at 'Humans vs the Robots' at the Pennybank Chambers, Clerkenwell, and in the window at the Paul Smith shop in Covent Garden
This page: *Characters* created for clients including *Shoreditch Twat*, *The Guardian*, *Time Out*, Perverted Science, Puma, MTV, Butterfly Effect and Cancer Research

ANDREW
RAE

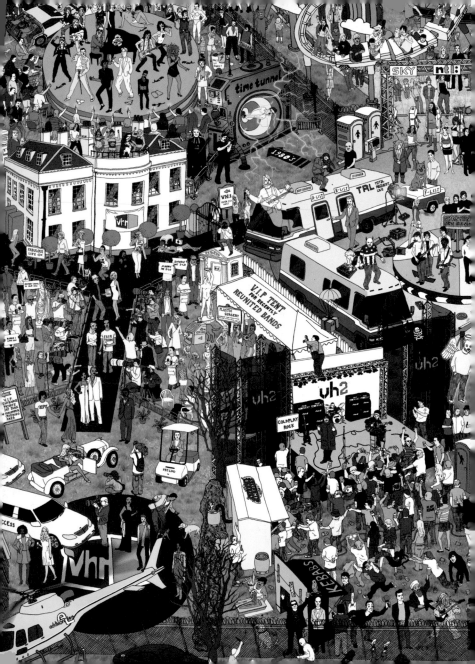

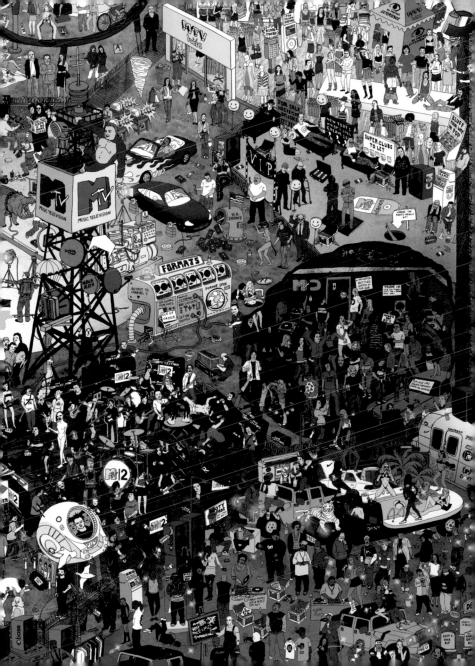

Previous page: *Music Television Festival*, promotional poster for MTV UK
This page: *In Coldblood*, personal work

James Graham_

'Work starts with me getting absorbed in the process. I use basic hand-rendered techniques, often laborious: print, pens, papers and copier machines. I draw inspiration from looking at old diagrams, atlases, encyclopaedias, instruction manuals and books on how things work. This combined with a fascination for journeys has led me to assemble an intricate visual world, navigating through micro/macro themes, communicating ideas that essentially evoke curiosity and simplicity. I enjoy the surprise of what comes next. Having just finished at the RCA, my aspirations for the future – besides untangling my own imagination and applying it to books and narratives or just using it for my own pleasure – is to be able to initiate projects with people. Whether I could create a series of maps for city ramblers, artwork for a local band, work alongside artists making a drawing together or running workshops, collaboration will be a catalyst for my artistic development.'

Opposite page: *Contours*, personal project
This page: *Domestic Squabble*, lithograph poster, promotional stationery

Motomichi Nakamura___

'Being a Piscean may explain my lifetime obsession with water and fish. As a child I fished in ponds and by the beach, I created my own fishing lures and was dedicated to my fish tank and my high school's official swimming team.

I can't describe exactly what it is about water and creatures that lurk in the dark that obsesses me to the level of constantly dreaming about them. A few months ago I visited the Fulton fish market in downtown Manhattan, only to find out

that it was moving its operations to the Bronx, which would make it much harder for me to stop by. That made me kind of sad.'

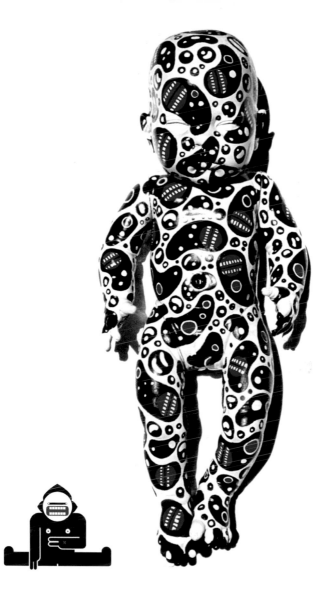

Opposite page, top: *Gaze*, from the 'Monster' series
Opposite page, bottom left: *Three Rices*, from MTV2.com intro animation,
©2005 MTV Networks
Opposite page, bottom right: *Daz*, personal project
This page, bottom: *Chaz*, personal project
This page, main image: *Dream Texture*, doll painted with sharpie marker

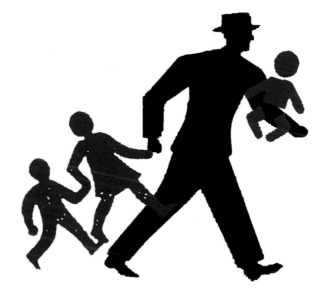

Opposite page: *Super-dad: modern-day fathers,* for *La Vanguardia* Sunday colour supplement, Barcelona, 2005
This page: *Immigration & bureaucracy: workman,* for *La Vanguardia* newspaper, Barcelona, 2004

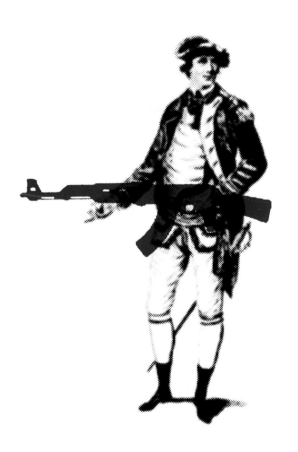

Opposite page: *Warfare*, personal project
This page: *Fox & hounds* (after Thomas Bewick), personal project

Spencer Wilson___

'Being left-handed gave me a natural leaning towards the creative arena and illustration is the perfect discipline for my "jack of all trades" attitude. At university we were taught how to generate ideas and encouraged to diverge from the preconceived ideas of 90s illustration. I've stayed true to that but my present work is a million miles away from what I produced then. New tools, particularly computers, have enabled me to find a style that balances flat colour, clean vector lines and space, occasionally juxtaposed with scanned textures. My desk is a controlled mess; thoughts and sketches on scrap paper, piled high, toppling down onto my laptop. I've found a comfortable method of working and obey certain rules (no feet or noses), but my work is continually developing. Competition for jobs is greater than ever, but my great friends at Peepshow keep me thinking forward. After all, doing the same thing every day gets to be a little repetitive, a little repetitive…'

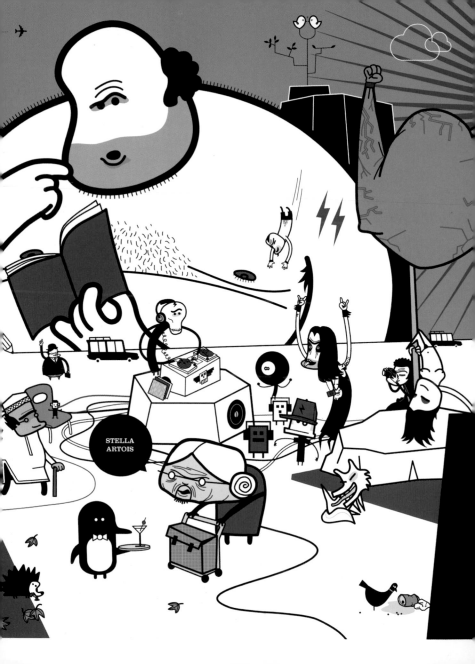

STELLA
ARTOIS

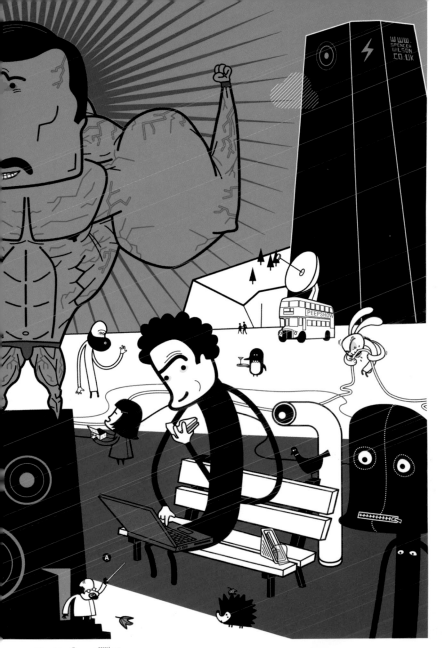

I lift things, a personal project for the Peepshow Summer Exhibition

Christoph Niemann

'I HATE DRAWING. The constant angst to mess it up drives me crazy. Trying to plan a complex cityscape on a piece of paper is plain torture – don't even get me started on trees. And then there is the queen of masochistic pastimes: likenesses. The rare moments in which I find myself enjoying the drawing process inevitably result in dull art. Of course practice muffles the suffering, and fortunately I usually don't have the time to indulge in my misery when battling deadlines and clients. Despite a certain serenity that I try to display when answering the phone, I find myself in a perpetually foul mood when I draw or think of ideas.

I LOVE BEING DONE. Here's the real beauty of drawing: unlike playing an instrument, you don't have to enjoy it while you do it. Seeing one's work in the paper the next day or finding a five-year-old sketchbook in a drawer, that's where the fun starts.'

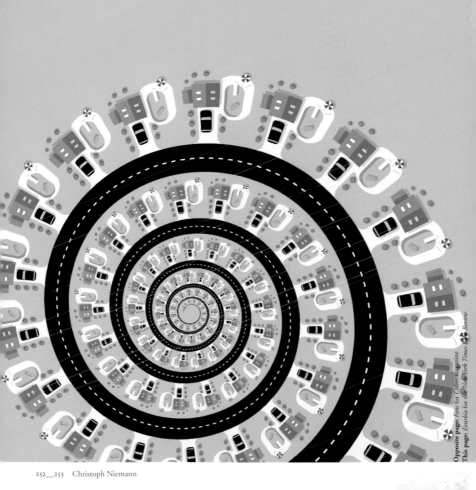

Opposite page: *Fans* for *Colors* magazine
This page: *Exurbia* for the *New York Times Book Review*

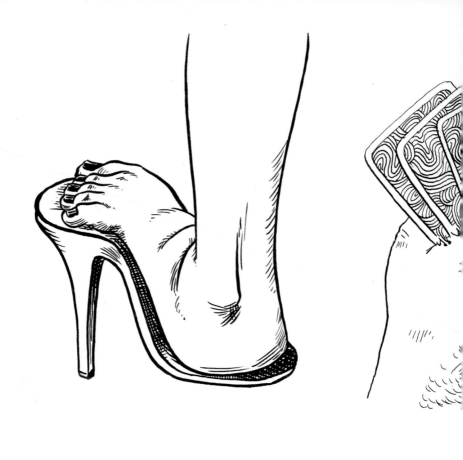

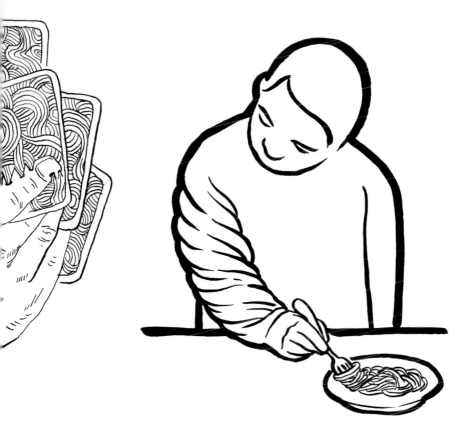

Three drawings from the book *100% EVIL* by Christoph Niemann and Nicholas Blechman, Princeton Architectural Press 2005

Chris Haughton___

'My illustration "career" began in Hong Kong. When I left college I didn't want to think about anything to do with drawings or computers for a while, so I went to Hong Kong. I found a job teaching English but after a while I wanted to get back into drawing (with a little less getting up in the morning). I put together a portfolio and then a website (vegetablefriedrice.com, which made no sense when I moved to London, but anyway ...). I turned up on the doorstep of

any company I could think of with a handful of drawings and not a word of Cantonese ... but they were all so nice. I met some amazing art directors over there. I think it was probably easier to start off there than in London. At the moment I'm living in London and designing prints for the fair-trade company People Tree. They pay me in T-shirts and notepads, which I sell on a glamorous market stall on Brick Lane on Sundays. If you're in London come over and say hello!'

Images from 'the story of vegetablefriedrice', self promotion for artist's website vegetablefriedrice.com

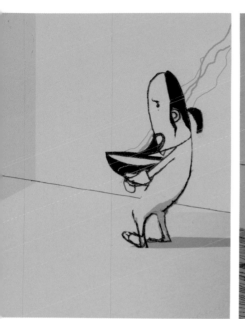

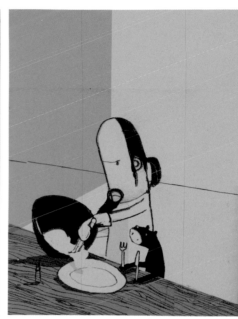

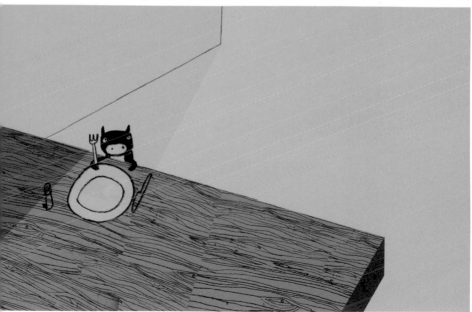

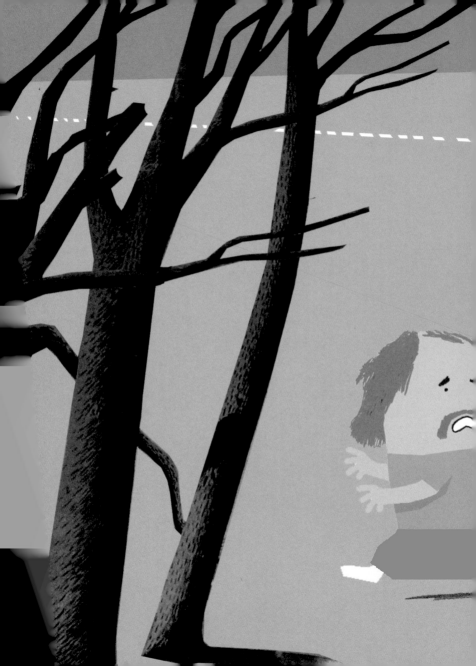

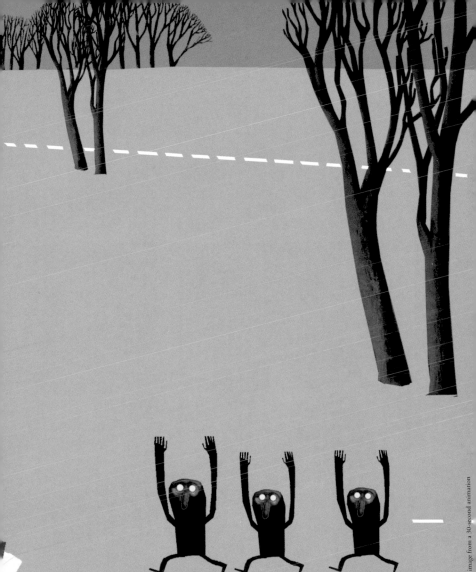

Tiny things in the park, image from a 30-second animation

Simone Lia___ 'I enjoyed painting and drawing at school. I felt like
I was in heaven when it was the art class although I wasn't that
good at it. My teachers really encouraged me and, thanks to
them, I went to art school and then got into illustration and
comics. I still enjoy drawing and painting a lot: sometimes it
can help me to understand and appreciate the world around me.
My hope is that my pictures might make someone feel happy or
something similar to happiness, even if it's just for a moment.'

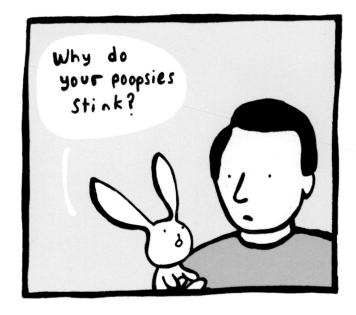

Opposite page: *Why do your poopsies stink?*, a frame from *Fluffy* part 4, a graphic novel published in four parts by Cabanon Press
This page: *Mr Sweetcorn Kernal* from a comic strip commissioned by *Amelia's Magazine*

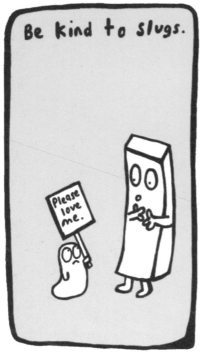

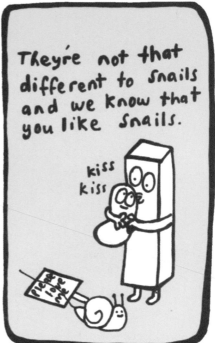

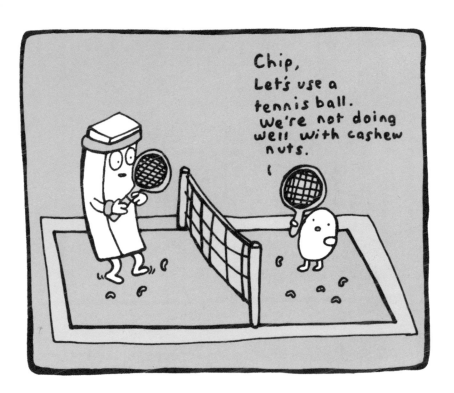

Nomoco_ 'To collect small thoughts and quiet noise. To catch those memories quickly before they start hiding from me. I've been making pictures in this way since I was small, I think.'

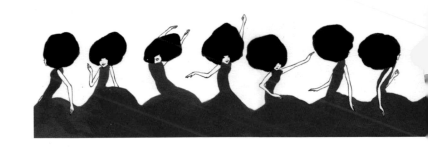

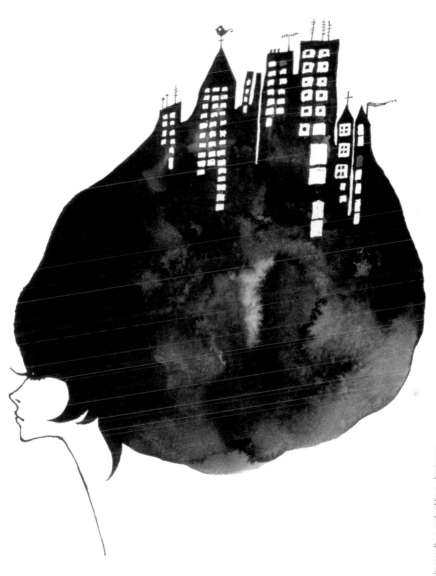

Opposite page: *Dance,* produced for an advertisement
This page: *Window #2,* for the Japanese magazine *Casa BRUTUS*

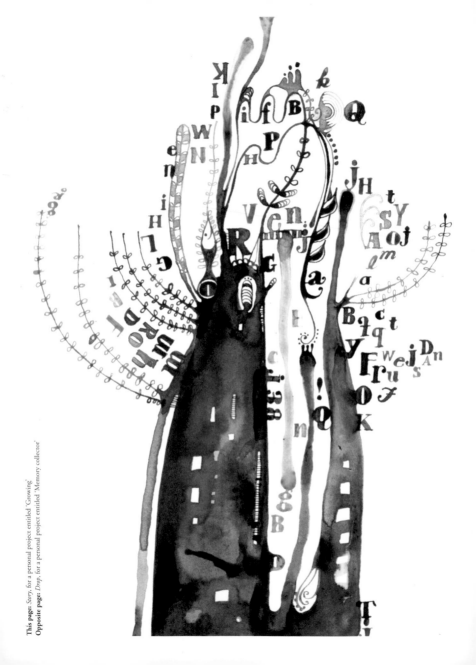

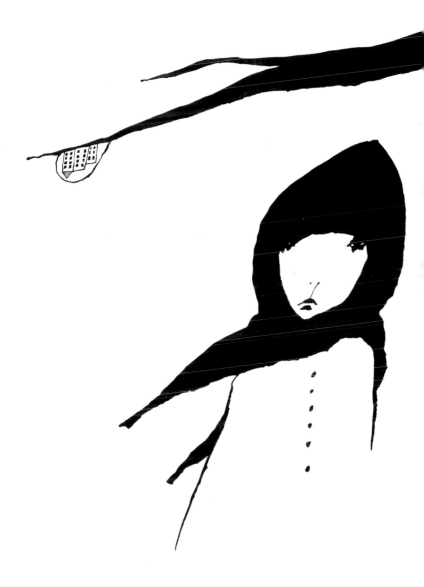

Valero Doval

'I like everything that opens my senses... Dreams...
Travelling... Discovering new places... It makes me reflect and
helps me to understand the world better.

I started to feel an obsessive fascination for the Far
East, particularly for Japan. I was taken by its strange alphabet
with unknown meaning, signs of colours and fanciful shapes.
I have never been there. I think that's why all this is a
tremendous source of inspiration for me.

I enjoy making artist's books and illustrations in
which I interpret and represent spaces, feelings and imaginary
trips to the Orient. They are unreal landscapes, objects, people
and rare animals. This is a way for me to get closer to these
unknown places.'

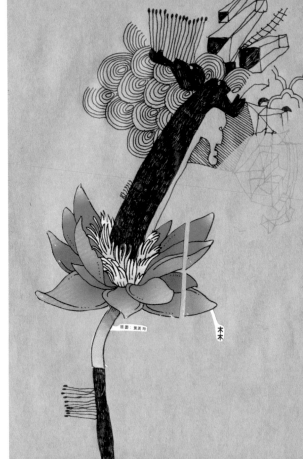

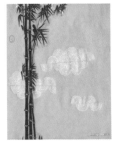

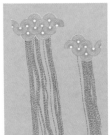

Opposite page: Japanese posters, illustration series from a personal project awarded in *Creative Review* magazine 2005
This page: illustration from an exercise book, personal project

Olivier Kugler___

'I always loved to draw. When I was a kid I loved comic books, such as *Tintin*, *Lieutenant Blueberry*, and even *Batman*. I still love them. I dreamt of becoming a comic book artist, so I spent a lot of time drawing/copying my favourite comic book heroes. After a while my dad – an artist and teacher – told me that if I wanted to learn how to draw I needed to stop using comic books and study real life subjects. He even took me to life drawing lessons as a birthday present.

I am inspired by the world around me, particularly the simple, banal things that are often overlooked, whether it's a cup of coffee or a cigarette butt on the street. I am also interested in photojournalism and, after resisting for a long time, I now work from photographs on a regular basis. In the future I see myself returning to observational drawing. There is something about drawing, a certain intimacy with your subject matter that can't be achieved with a camera.'

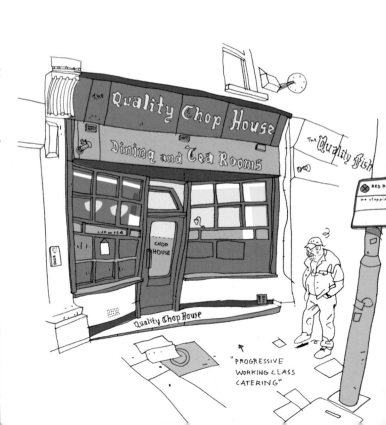

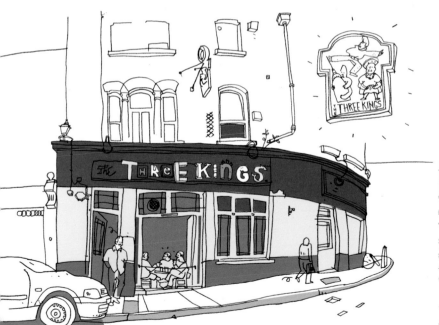

Opposite page: *Quality Chop House*, for *Time Out* magazine
This page: *Three Kings*, for *Time Out* magazine
Following page: *Mr Ren's bicycle repair shop*, for a Shanghai special in *The Guardian's G2* supplement

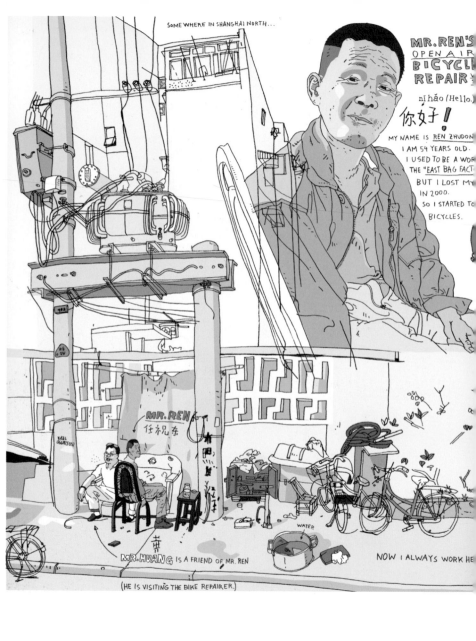

SOMEWHERE IN SHANGHAI NORTH...

MR. REN'S
OPEN AIR
BICYCLE
REPAIR

ni hǎo (Hello.)
你好!

MY NAME IS REN ZHUDON
I AM 54 YEARS OLD.
I USED TO BE A WOR
THE "EAST BAG FACT
BUT I LOST MY
IN 2000.
SO I STARTED TO
BICYCLES.

MR. REN
任祝东

WATER

MR. HUANG IS A FRIEND OF MR. REN

(HE IS VISITING THE BIKE REPAIRER.)

NOW I ALWAYS WORK HE

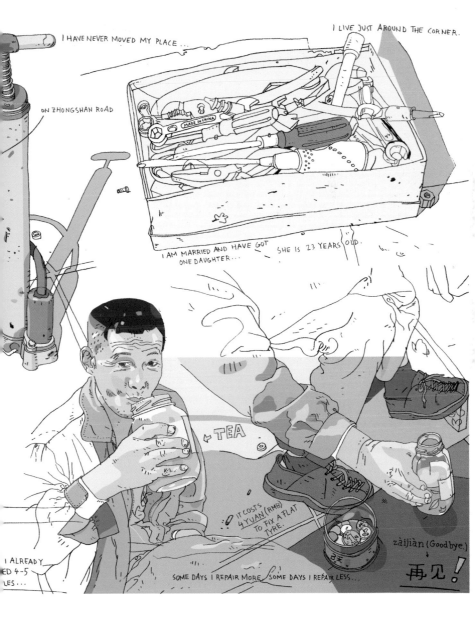

Tomer Hanuka___

'I grew up in the mid-1970s reading superhero comics and quickly fell in love with the illusion of the world functioning in four-colour half-screens. Things turned sort of grey when, at 18, I was drafted into the army for three years, which is mandatory in Israel. 18 is a crucial age to freeze anyone's potential but it gave me time to plan and when I left I couldn't sit still for a second. The first thing I did was travel to New York and go to the School of Visual Arts. I liked walking around areas of the city I hadn't seen. It helps me to think clearly, and I find inspiration in seeing a familiar universe organized in a new way. On the page, I like drama. I like telling a story in one scene, in which there are different points of view and the situation boils towards a climax, where opposing motivations clash. I like to manipulate the eye and control the way we interpret the hierarchy of importance and impact within a visual narrative.'

Aesop Rock / Bazooka Tooth, album cover

Yuko Shimizu___

'I've been drawing ever since I can remember but as an illustrator I was a VERY late starter. I have a degree in marketing and advertising and my parents were concerned that art school was a death sentence to forging a career. I worked in a Tokyo trading company, commissioning illustrators for ad campaigns and report covers and one day I thought, "I wish I was doing that". I was already ten years into my career, so it was now or never: I enrolled at the School of Visual Arts in New York. My

parents are fine with me being an artist now, because I can pay all my bills. In my work, I see many similarities with my childhood drawings but I also see how different they are. My work is constantly evolving but some things never change. I don't believe in "finding a style". An artist should always think of changing and evolving, but also we shouldn't fight against things that won't change. Style isn't something you should desperately seek.'

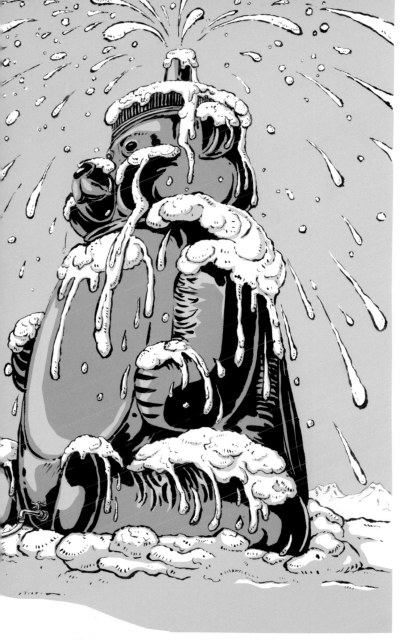

Snow Machine 2003, from a personal series
'Little Red Polka Dots and Other Stories'

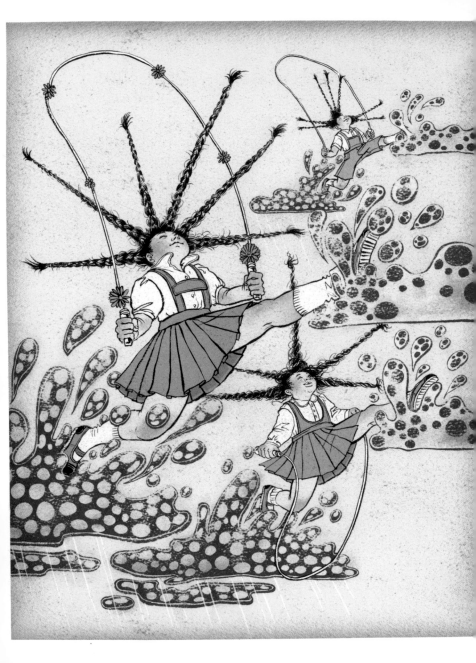

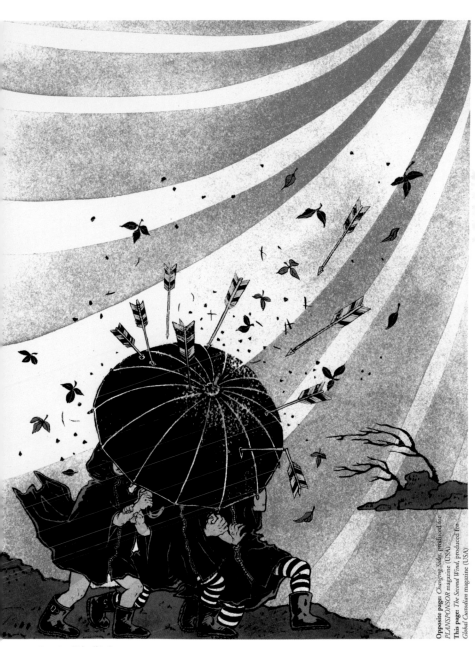

Opposite page: *Changing Sides*, produced for
PLANSPONSOR magazine (USA).
This page: *The Second Wind*, produced for
Global Custodian magazine (USA)

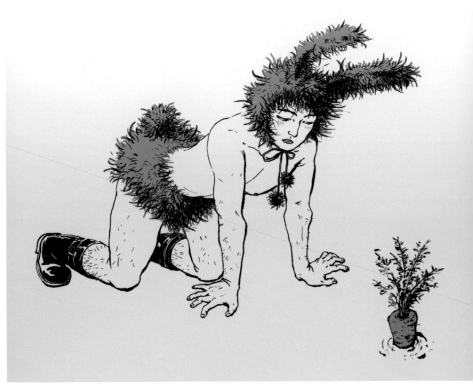

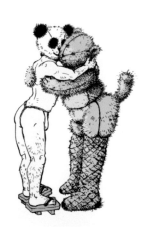

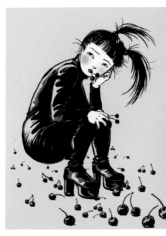

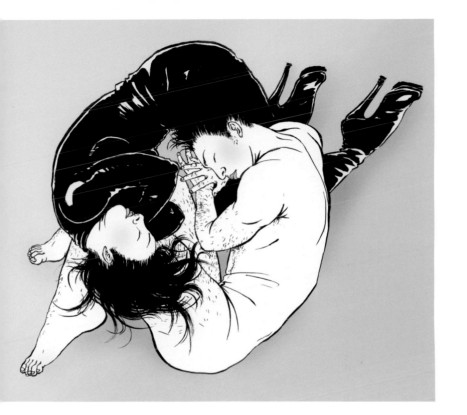

Opposite page, top: B – *Bunny Boy in Black Biker Boots*
Opposite page, bottom left: F – *Fluffy Fascination*
Opposite page, bottom right: V – *Virgin in Vinyl*
This page: Y – *Ying and Yang*
All illustrations for a personal alphabet book project, 'Letters of Desire'

Graham Rounthwaite___

'Hi, I'm Graham, I'm 21 and I've got high scores on *Megaman 2* and *Escape to Krelonder*. I'm top five on *Attack of the Marblemen* and *Chia Bomber 2*. I played a bit of *Zelda* and did the unthinkable and set an Untied Nai WR in *Zelda V*, finally beating the old 58 seconds in *Marathon Run*. I also reached level five, scene six in *Multi Racing Championship* and posted *Perfect Dark* stats, so I'm ranked second now.

There is a rankings system that accumulates all the top five places gained by players in all the normal rankings. In all honesty I'm really not the best player on these rankings, although I have got three top five spots. I have a best time for *1080 Snowboarding* (not including *Trick Attack*) of one minute 57.5 seconds including a new Nai WR for the very first level! Everyone can tell that this is the tightest packed level of them all, with just 0.40 seconds separating first and tenth (which, btw, is a tie).'

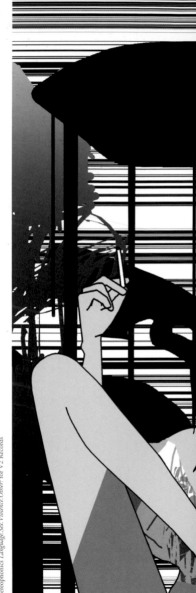

Stereophonics *Language.Sex.Violence.Other?* for V2 Records

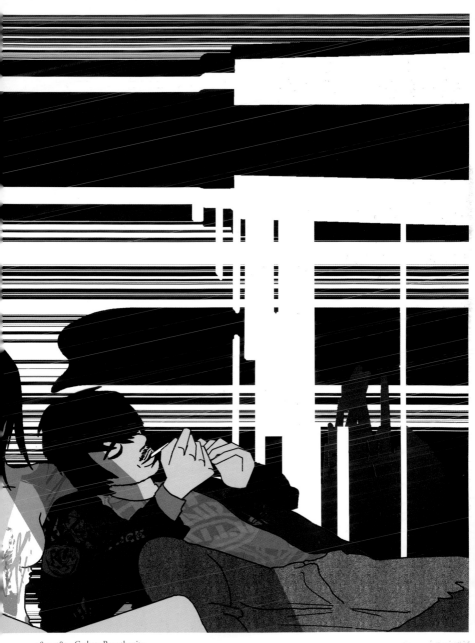

Graham Rounthwaite

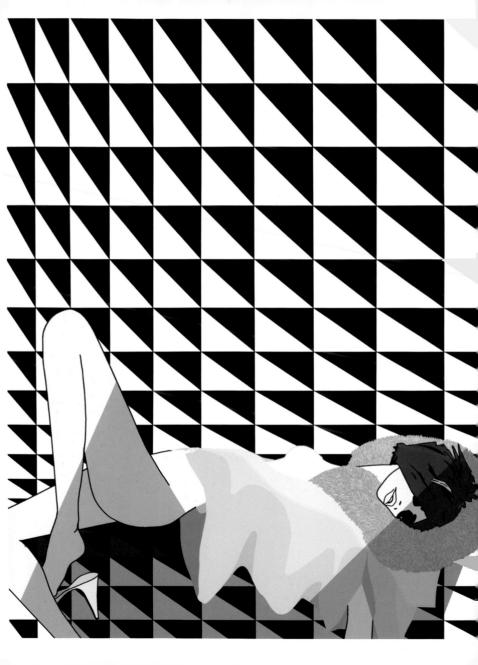

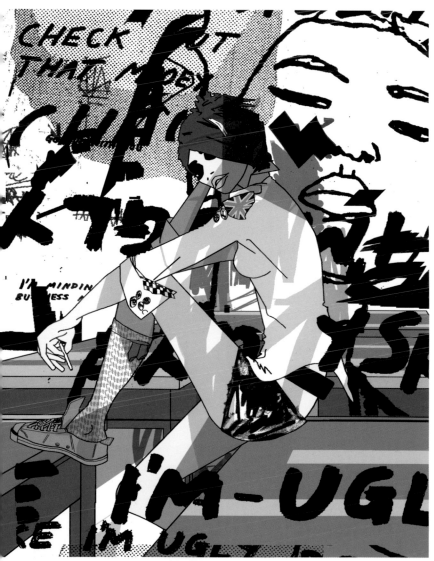

Opposite page: *Ungaro SS/04, Donna Magazine,* Italy
This page: *Off-centre,* London

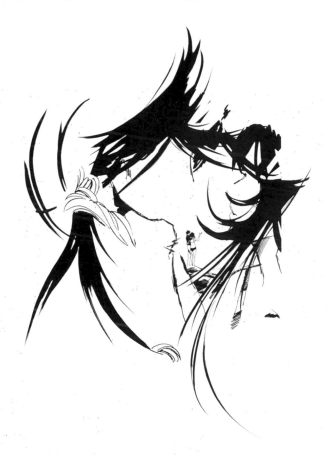

Laurent Fetis___ 'I'm drawing because of the vision of the works of Richard Scary, Chris Foss, Pierre Bonnard, Albert Oehlen, Philip Castle, Robert Crumb, Tanino Liberatore, Charles Burns, Raymond Pettibon, Frank Lloyd Wright, Katsuhiro Otomo, Piranesi, Heinz Edelmann, Gustav Klimt, Kim Deitch, Martin Kippenberger, Yakatsuma Eye, Edgar Degas, Jake and Dinos Chapman, Saul Bass and Osamu Tezuka – all of whom have, at one time or another, opened my mind.'

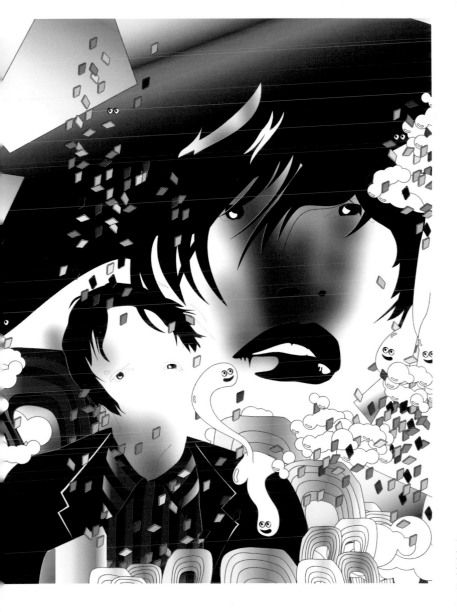

Opposite page: *Untitled*, ink drawing
This page: *Sex & Drugs*, illustration for *The Face* magazine

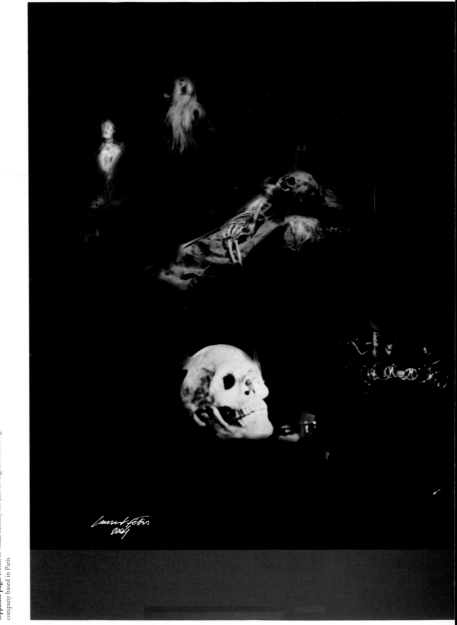

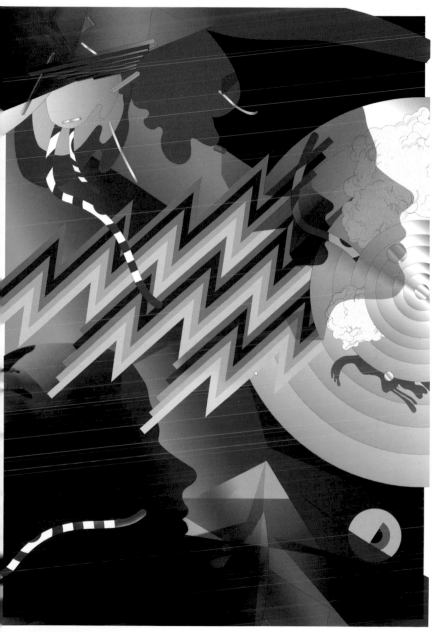

Stina Persson___

'One of my teachers said "for every good painting you need to make ten bad ones". That has saved my sanity many times. It takes lots of work to get it right and make it feel effortless, beautiful but not slick. It began with drawing and painting my way through childhood – usually girls wearing colourful, intricate hats and sporting round, jovial cheeks. When I realized I was alone with this obsession, it was already too late. Later, after years in different art schools – where pretty girls were considered a *faux pas* – they returned. In an apartment in a gritty, grey New York neighbourhood, they seemed okay again. The hats and cheeks had gone and they'd acquired some grime and edge. I painted them on large-scale canvases and sold them to friends a little better-off than me. Eventually, they found their way into my illustration. I still like girls today: to paint and maybe even to look at. And today they pay my rent. And the diapers for my two baby sons.'

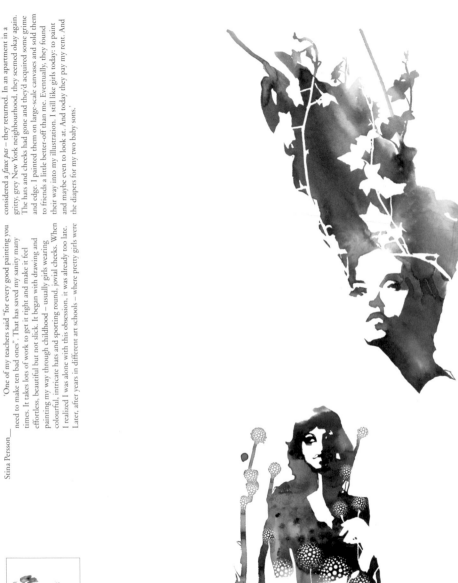

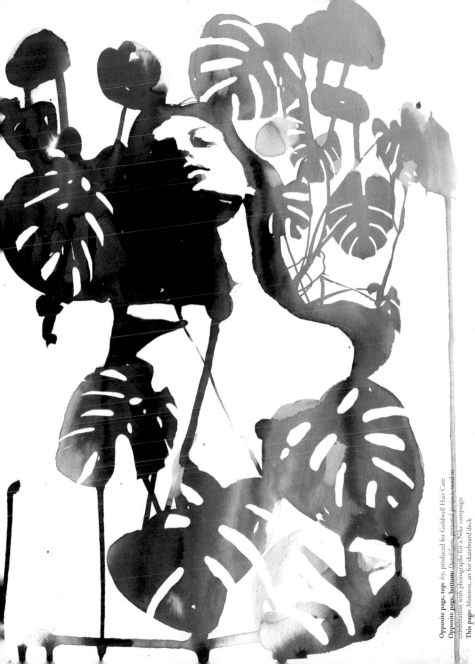

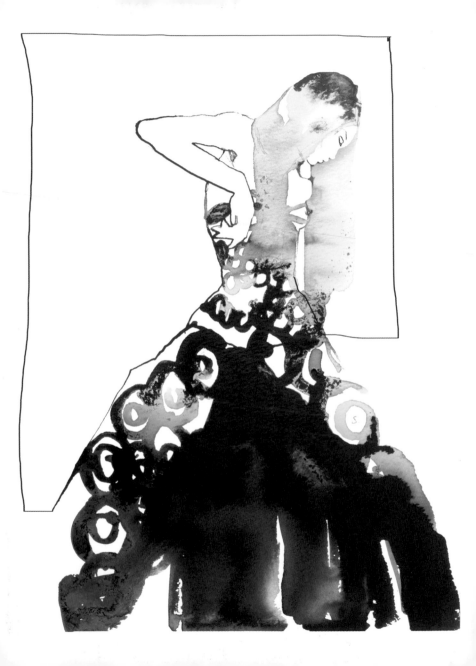

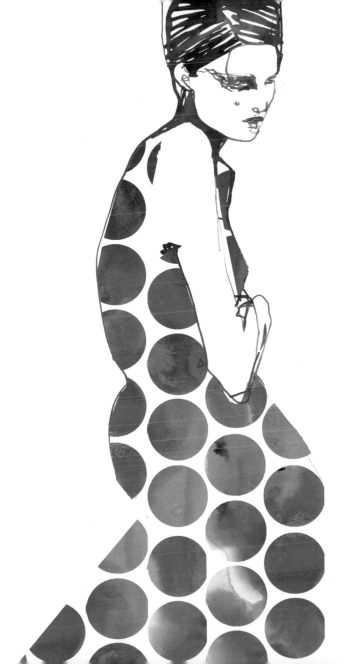

Opposite page: *Versace Haute Couture*, German Amica
This page: *Circles*, Christmas card design

Rubens Lp___ 'I'm from the third world. My work is based on my life. I don't know anything about theories. I don't want to be "THE ARTIST". I am what I say in my work. Sometimes I work for food. Yes, I have ambitions. I have drawn since I was five years old (I think ...). I drew the strongest men and the most beautiful chicks. Japanese people too. Everything around me and my damaged head. Art is my passion. I live for my art. I don't know how to make anything else.'

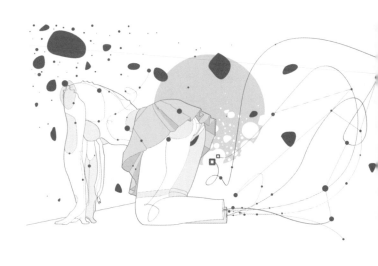

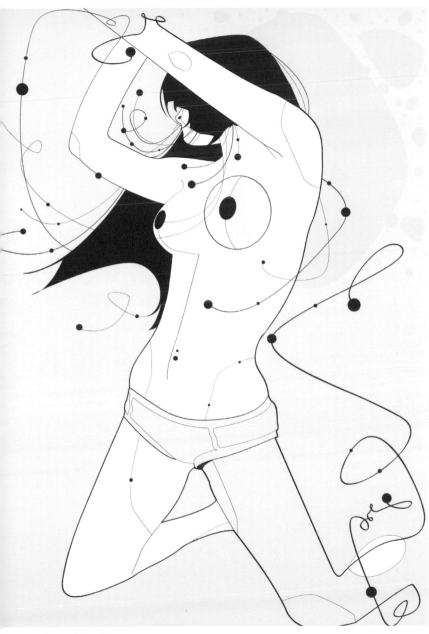

Opposite page: *Dogstyle*, personal project
This page: *Dance all night*, personal project

Tommy Penton___

'I've always wanted to draw. Art was the only subject I excelled in at school. I'm totally dyslexic. I once met somebody who claimed they knew this just by looking at my work! How I became a *bona fide* illustrator: I was working as a designer at a company called BlackSun, and a project came in to create a mural for British Airways. They asked me to illustrate it in-house and I was like "fine, I can do that". I spent a week on the job and I hadn't enjoyed a week like that for years. Three months later I left BlackSun and committed myself to illustration. I'm really inspired by new places. I love to go places and just absorb things. I worked in Sydney for a while and the colour of the sky over there is so different. I think that's the kind of thing that drives me and inspires fresh ideas. Travelling has definitely helped me develop as an artist.

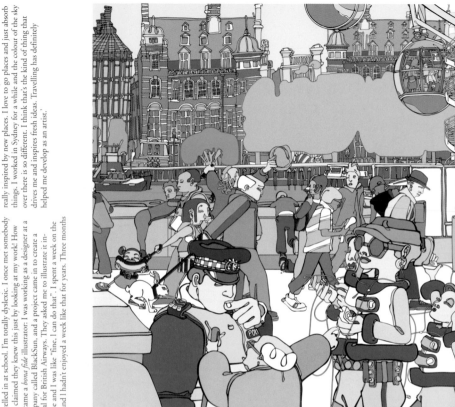

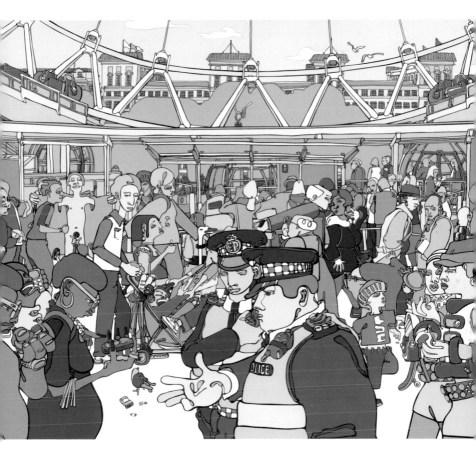

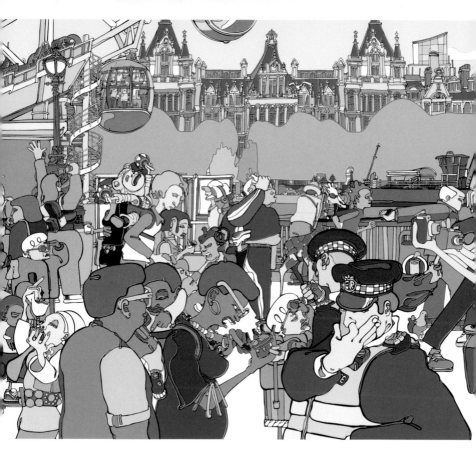

Opposite page: From the book *A Long Walk*
This page: 1 of 10 from the Banani series

Genevieve Gauckler_

'As a child, I enjoyed drawing horses and German army helmets. I played football with my two older brothers and my favourite TV series was *Flipper* (the dolphin). I got so bored at school that I couldn't help keeping drawing horses on schoolbooks. As a teenager, I saved my money to buy *The Face* and *ID* magazine and at art school I was amazed by the work of English graphic designers such as Peter Saville, Neville Brody, Vaughan Oliver, Designers Republic and Me Company.

I wanted to do the same kind of cool stuff. Then I started working on my own, designing record covers for the French label F Communications. I've been working for 15 years and I still enjoy it because I'm learning all the time. I'm more into illustration now, character design and motion graphics (with Pleix collective), but I still draw horses when I'm on the phone.'

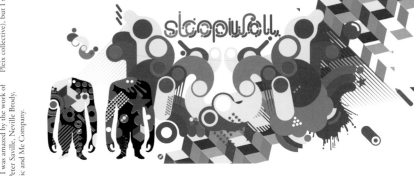

An angel has passed here.

An angel is passing here.

Good night.

're fab.

I love you.

Opposite page: *Sleepwell*, design for a room in the Fox Hotel, Copenhagen
This page: *Guardian Angels*, design for a room in the Fox Hotel, Copenhagen

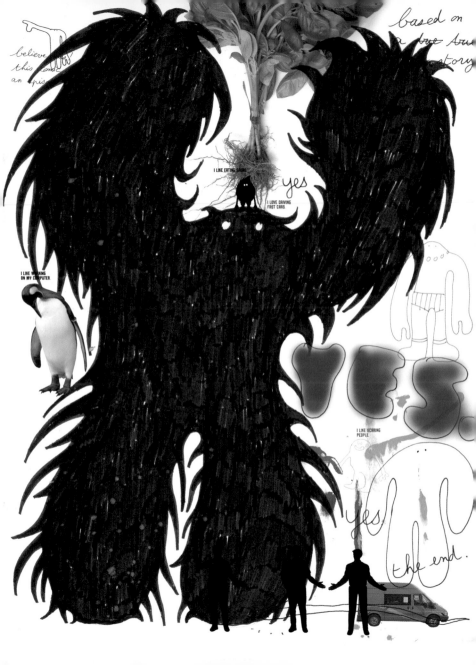

believe
this
an

based on
a true true
story

I LIKE EATING SAUD

yes

I LOVE DRIVING
FAST CARS

I LIKE WORKING
ON MY COMPUTER

YES.

I LIKE SCARING
PEOPLE

yes

the end.

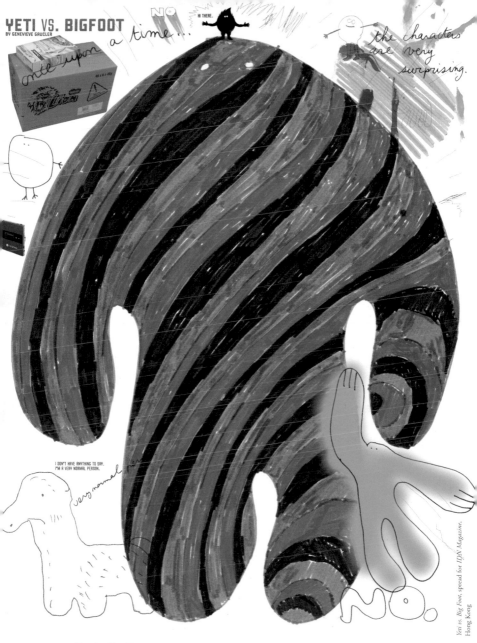

YETI VS. BIGFOOT
BY GENEVIEVE GAUCKLER

once upon a time...

NO

HI THERE.

the characters are very surprising.

I DON'T HAVE ANYTHING TO SAY. I'M A VERY NORMAL PERSON.

very normal

NO.

Yeti vs. Big Foot, spread for IDN Magazine, Hong Kong

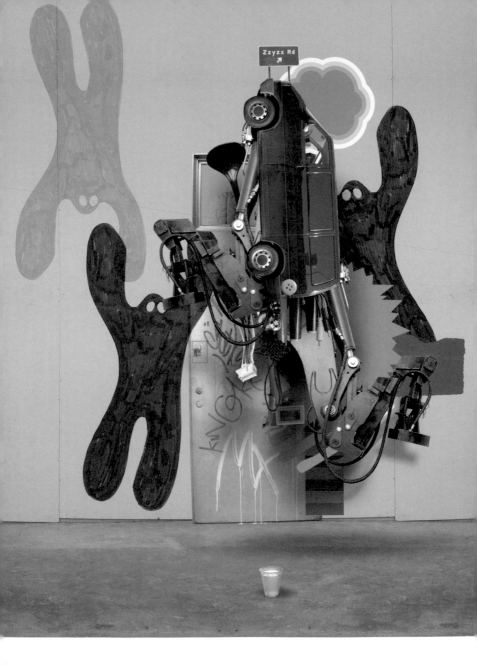

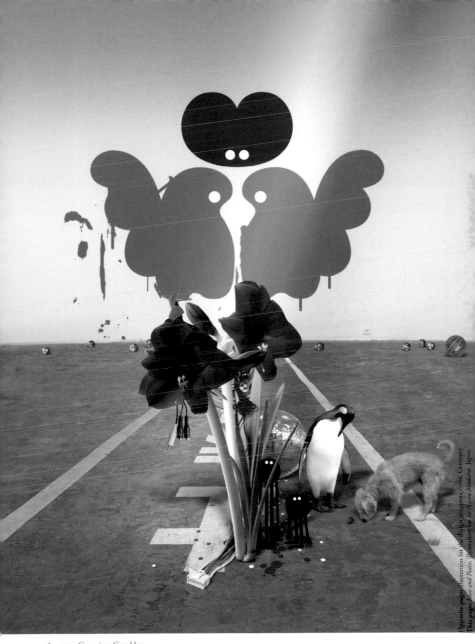

Opposite page: illustration for pie design magazine *form*, Germany
This page: *Love and Peace*, illustration for *Le Theatre Madame*, Japan

Container_

'It's all in the details: overweight squirrels in bikinis, hotel rooms with panthers on chains and kings with wallpaper trousers, devil babies, a car with a large exotic lady lying across the bonnet and fields with horses and batteries in the background. Our worlds grow and fester according to our own internal logic. The starting point may be a simple misunderstanding in a conversation or a website for animals in fancy-dress costumes. Then there is no escape – the idea takes over and becomes a living organism sprawling across the screen, the page or the wall. So does the mess, unfortunately. When it all gets too much we usually attempt to regain control with extortionate amounts of glue. And if that doesn't work (it usually doesn't) a tea break with cake tends to infuse sufficient composure for us to successfully tackle the insurgency of unruly squirrels.'

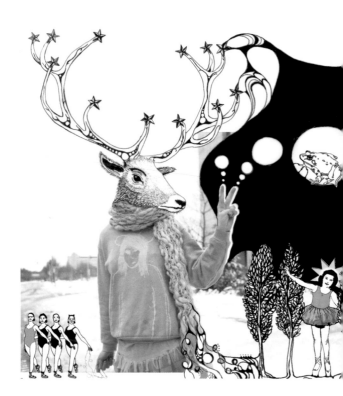

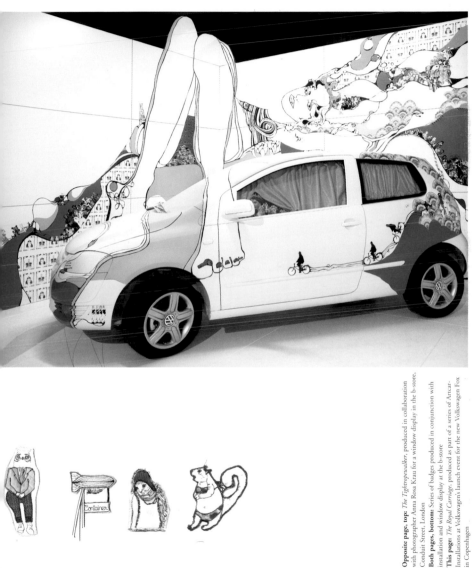

Opposite page, top: *The Tightropewalker*, produced in collaboration with photographer Anna Rosa Krau for a window display in the b-store, Conduit Street, London

Both pages, bottom: Series of badges produced in conjunction with installation and window display at the b-store

This page: *The Royal Carriage*, produced as part of a series of Artcar Installations at Volkswagen's launch event for the new Volkswagen Fox in Copenhagen

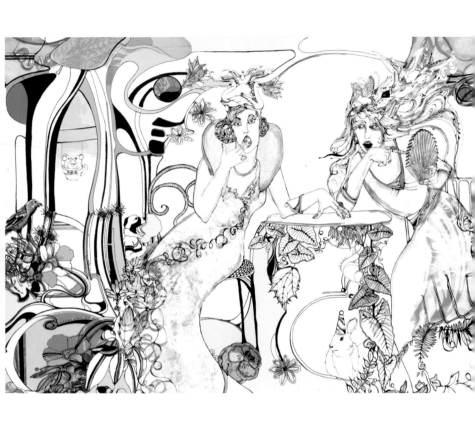

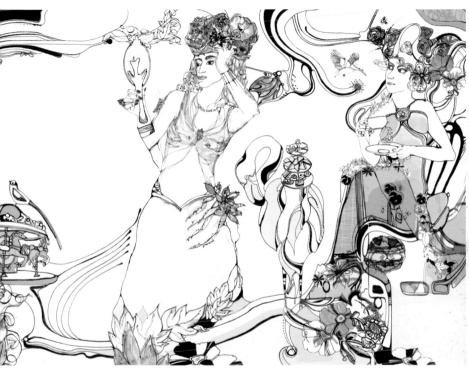

The Mad Hatter's Tea Party, produced for the redesign of Selfridges LAB café on the second floor of the London department store

Bernie Reid_

'Time stretches and space folds. Nebulae burn brightly and stories of fantasy camps for frustrated artists are told ... Some say it's a myth to keep art alive "to help one puncture the iron curtain of predictability" and the pencil of no variety cannot exist on any plane. The art is inside and can't be explained. I mean, how do you outline something if it's shapeless and hapless? How do you bring light to the world when your best friend is a hovering cloud and that crumb in

your beard is the atlas! Circles can be vicious and straight lines a waste of time ... But our hero's pendemonous strokes tear the surface of the moon. Changing the look of art forever as he quiets his mind and steadies his hand. With a twist of his art mechanic's monkey wrench, he unknowingly becomes the point of gravity that space bends around. Welcome to the planet that is Bernie Reid. Painting out loud.'

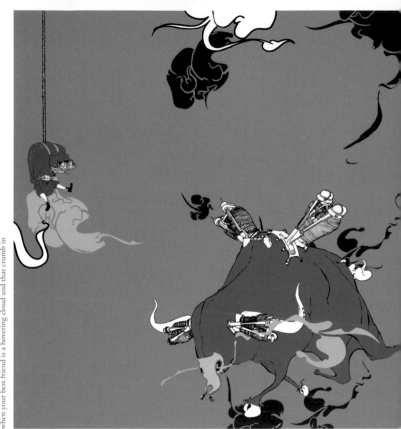

Art Mechanics, EP cover for the Penpushers

Void Engineers, EP cover for the Penpushers

Jeremy Tankard

'Like most "artists" I know, I've been drawing for as long as I can remember. At school I had an English sketchbook, a history sketchbook, a maths sketchbook.... you get the idea. I like my drawings to be deceptively simple, to show a rich, multi-layered world with moments of radiant beauty or humour pulsing through it. More than anything, I try to make sure my drawings reflect the sheer fun that goes into making them. I believe that the best illustration comes from someone in tune with themselves and the world around them – someone with a singular "voice" who speaks of the artist's unique place in the world. It's important to find one's own voice through years of patient self-exploration rather than the usual method of studying other illustrators or techniques, no matter how successful they are. Perhaps by the time I'm 90 I'll have found that unique vision, in the meantime it's a lot of fun trying.'

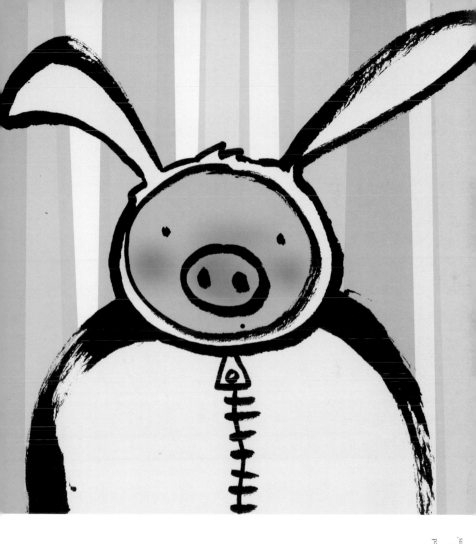

Opposite page: *Forest Fire*, produced for *Wild Outdoor World* magazine
This page: *Pork Bunny*, illustration for a recipe in Alberta Pork Producers' *Food for Thought* magazine

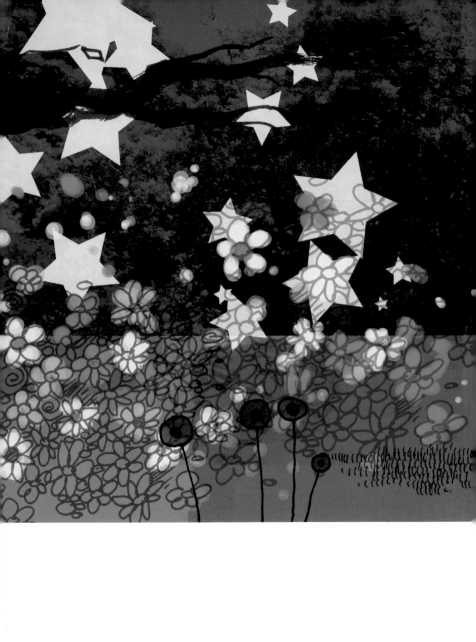

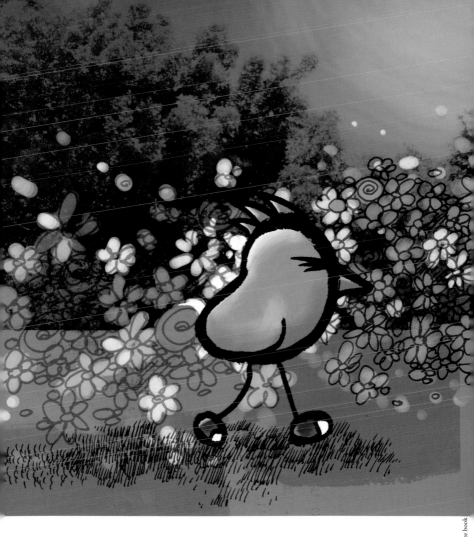

Bird Takes a Walk, study for a picture book

Diane Barcelowsky___

"'From shadows of forgotten famous Polish pedigree emerges the artist. What is drawn is drawn, and these are forever songscapes, recapitulating Noah's beasts now dancing, now prancing upon loose leaf boughs, treasure folded in fanciful brushwood pen-work. Oh, for the love of the impoverished artist, please sing a song of six-pence, or spare more, for the artist has forgone her ashen spirit in return for this body of pleasure pictures. Beholden are we, dear readers. Here lies the spook of loons perched in a shady timber: look out below! Crowds fall from the thick of the air. There stood a hood of roof beams raised high, inside the dream of a long-since scene: the sky is the limit! Ships like snowflakes set to sea-fare. Imagine the great ecstasy of the artist as soothsayer, the motif of the hourglass lately inverted, and – ladies and gentlemen, children of all the ages – we are as the timeless spots in this latter-day looking glass. Come, gather together upon these grounds and sing the artist's praises.' – Anonymous'

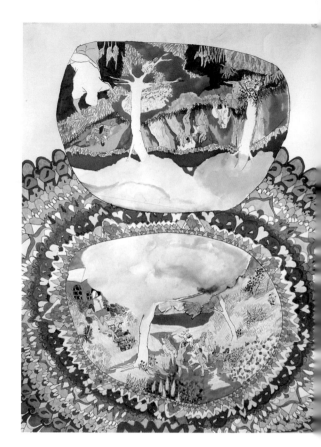

Opposite page: *Untitled #2*, personal project
This page: *Devil holding head*

Opposite page: *Four ladies,* personal project
This page: *People with lions,* personal project

Sara Fanelli___

"'You can discover more about a person in an hour of play than in a year of conversation.' Plato

My mother showed me how to use scissors when I was little. On a bright orange table she would make cutouts and pictures as if by magic. I enjoy the playful and unexpected combinations that appear while I am working on a collage. I love to be surprised, letting the pieces of paper and the colours take over and suggest a picture that could not have been

imagined at the outset. Also I like creating other worlds in books. Playing with the sequence of images, sometimes repeating and sometimes startling. And letter forms, sometimes like insects, sometimes like flowers, sometimes like old-fashioned moustached men. Typography contains other games. Unfortunately, at times, even playing can get frustrating; but how lucky we are if we can be making pictures every day.'

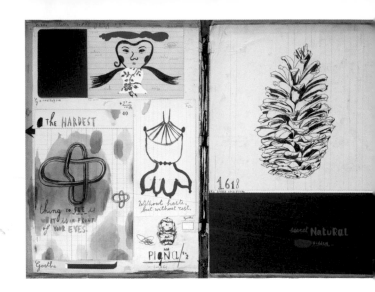

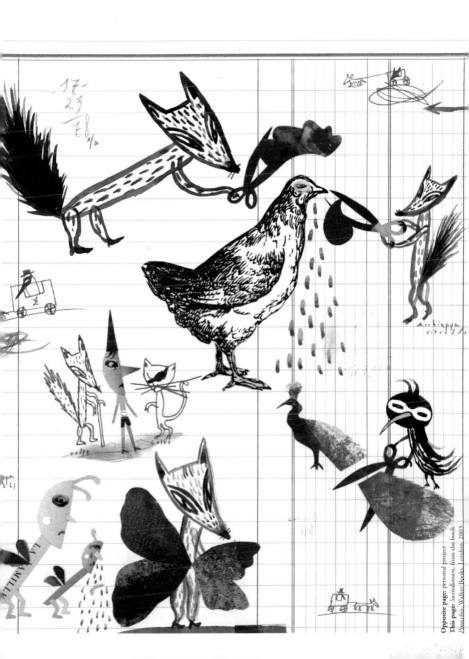

Opposite page: personal project
This page: *Swindlimon*, from the book
Pinocchio, Walker Books, London, 2003

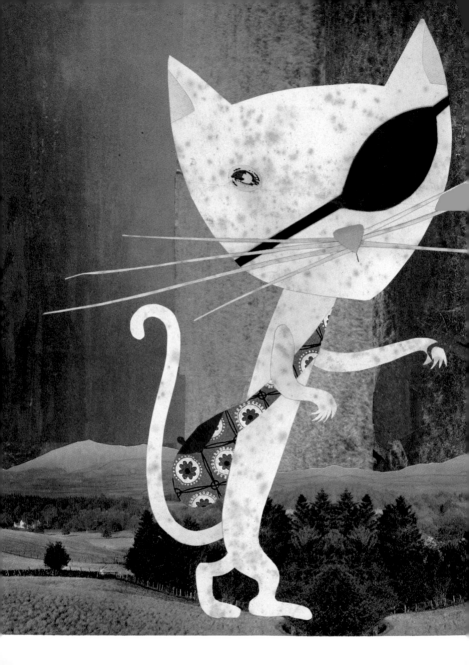

The Cat and the Fox, from the book Pinocchio,
Walker Books, London, 2003

2

pour

Mythological monsters endpapers from the book
Mythological Monsters of Ancient Greece, published
by Walker Books, London, 2002

Harriet Russell____

'I've been drawing all my life and wanted to be an illustrator ever since I wrote and illustrated one of my first stories at the age of eight. *The Black Teeth* was about a family who steal and eat all their children's sweets whilst they are asleep. I've progressed a little since then, although my ideas are now even sillier. In my alphabet book, for example, "A is for rhinoceros", "K is for fish with an umbrella" and "G is for broad bean pierced by a fork with uneven prongs".

I'm inspired by lots of things, especially the surreal, the strange and the slightly odd. I also have a strong interest in hand-drawn lettering, which often crops up in my work; work which I'd generally describe as quirky and slightly surreal with a subtle sense of humour and a style that is graphically simple and immediate. Ideas are very important to me and the stranger they are the better.'

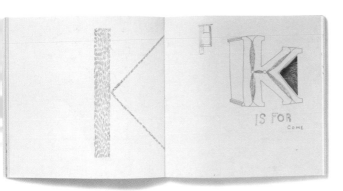

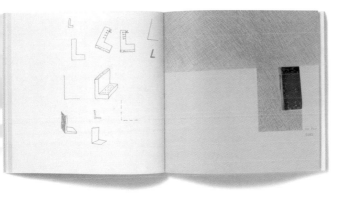

Opposite page: top: *M is for...*; **bottom:** *C is for...*
This page: top: *K is for...*; **bottom:** *L is for...*
All double-page spreads from *A is for Rhinoceros* by Harriet Russell

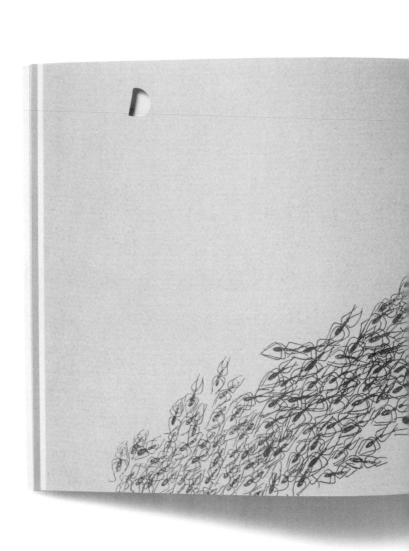

C is for Insects from *A is for Rhinoceros* by Harriet Russell

Roderick Mills___

'Verbal communication was very difficult for me as a child; I constructed my own visual world to inhabit. At age five, I spent about a year off school due to illness. There was no homework, so my parents gave me biro pens, felt-tip pens and an unlimited supply of second-hand printed paper to draw on the back of. Drawing whilst watching television became second nature. I loved rushing home from school to watch *Godzilla* films and any news footage of *Apollo* 17 and the *Apollo-Soyuz* space mission. At age eight I won a national painting competition sponsored by Penguin Books. I was called out of morning assembly fearing the worst, thinking I had done something wrong but, instead, I was praised for my picture of George and the Dragon. At age 18 I failed my art A-level. Illustration has given me a voice.'

Opposite page: illustration for *New York Magazine*, for an article about those awkward questions parents face from their children
This page: *A is for Acquisitions*, illustration for an annual report designed by Lippa Pearce

LE ROYAL MERIDIEN BIC PEN

GMB NATIONAL COLLEGE

PILOT

WWW.JOINAMNESTYNOW.ORG.UK

ZEBRA SARASA 0.7 MEDIUM

THE CO-OPERATIVE BANK PEN

PAPERMATE P

ZEBRA SARASA 0.7 MEDIUM

ASA 0.7 MEDIUM

ECONO DX T6

PILOT BPS FINE

PAPERMATE MEDIUM PT. USA

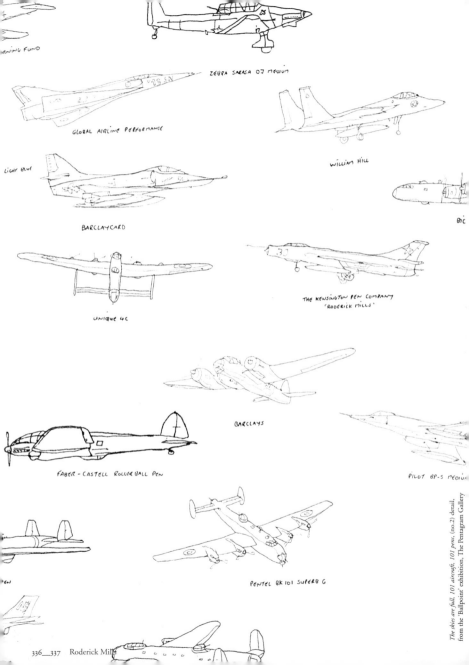

NING FUND

ZEBRA SARASA OJ MEDIUM

GLOBAL AIRLINE PERFORMANCE

WILLIAM HILL

LIGHT BLUE

BARCLAYCARD

BIC

UNIQUE 4C

THE KENSINGTON PEN COMPANY
'RODERICK MILLS'

BARCLAYS

FABER-CASTELL ROLLERBALL PEN

PILOT BP-S MEDIUM

EN

PENTEL BK101 SUPERB G

The skies are full. 101 aircraft. 101 pens, (no.2) detail,
from the 'Ballpoint' exhibition, The Pentagram Gallery

Christine Berrie___

'Discarded drawings from my dad's office, where he worked as a draughtsman, provided me with my earliest canvases. The reverse sides of these huge plans were to feature my childhood sketches and doodles. A few of the plans have been kept, showing intricate mechanical drafts on one side and crudely drawn crayon faces on the other.

Currently, everyday scenarios and objects are my favourite subject matter and I've long had an interest in trying to include a lot of detail in my drawings. But one thing that remains from my childhood is the simple pleasure found in making marks on a clean piece of paper, embellishing the first page of a new sketchbook with a quick drawing, sketching an outline or composing an image that spreads across a whole sheet of A3; the satisfaction of filling a blank space.'

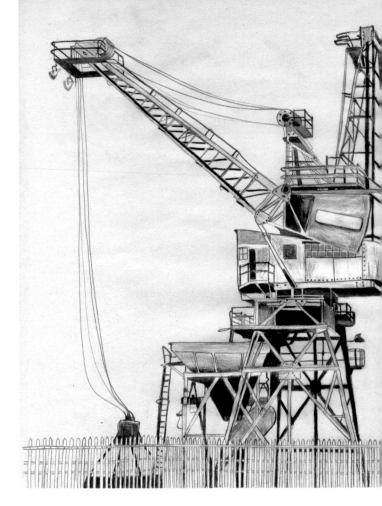

Cranes, personal project

This page: *TV*, commission for Howies
Opposite page: produced for *Off the Wall*,
an exhibition at the Pentagram Gallery

Contacts

Airside *studio@airside.co.uk*
Ceri Amphlett *ceri@ceriamphlett.co.uk*
Antoine et Manuel *c@antoineetmanuel.com*
Peter Arkle *sparkle@mindspring.com*
Alan Baker *mralan.baker@virgin.net*
Diane Barcelowsky *diane@thediane.com*
Christine Berrie *info@christineberrie.com*
Nicholas Blechman *nb@knickerbockerdesign.com*
Isabel Bostwick *bee@isabelbostwick.com*
Anthony Burrill *anthony@friendchip.com*
Nina Chakrabarti *nina@ninachakrabarti.com*
Travis Chatham *fat1cat@hotmail.com*
Astrid Chesney *astrid@astridchesney.com*
Deanne Cheuk *Neomuworld@aol.com*
Michael Comeau *comeaumichael@hotmail.com*
Container *info@containerplus.co.uk*
Agnes Decourchelle *mail@agnesdecourchelle.com*
Marion Deuchars *info@mariondeuchars.com*
Valero Doval *valero@valerodoval.com*
Sara Fanelli *sara@sarafanelli.com*
Laurent Fetis *info@laurentfetis.com*
Lizzie Finn *bianca@biancaredgrave.com*
Daisy Fletcher *daisy@daisyfletcher.co.uk*
David Foldvari *hello@bigactive.com*
Genevieve Gauckler *hello@bigactive.com*
Tom Gauld *tgauld@hotmail.com*
Kate Gibb *hello@bigactive.com*
Michael Gillette *m.gillette@sbcglobal.net*
Jasper Goodall *hello@bigactive.com*
James Graham *info@firstnamejames.com*
Tomer Hanuka *tomer@thanuka.com*
Chris Haughton *chris@vegetablefriedrice.com*
Alan Heighton *me@alanheighton.co.uk*
Nick Higgins *nick.higgins@virgin.net*
Boris Hoppek *boris@borishoppek.de*
Santiago Iturralde *info@santiagoiturralde.com.ar*
Benoit Jacques *Benoit.Jacques@wanadoo.fr*
Billie Jean (Sam Piyasena) *sam@billiejean.co.uk*
Izzie Klingels *izzie@izzieklingels.com*
Olivier Kugler *olivier@olivierkugler.com*
Simone Lia *simone@simonelia.com*
Rubens Lp *falecom@rubenslp.com.br*
Joe Magee *magee@periphery.co.uk*
Carolina Melis *caro@carolinamelis.com*
Roderick Mills *roderick@roderickmills.com*
Motomichi Nakamura
 motomichi_nakamura@yahoo.com
Christoph Niemann *mail@christophniemann.com*
Nomoco *info@pocko.com*
Reggie Pedro *www.reggiepedro.com*

Tommy Penton *info@tommypenton.com*
Stina Persson *agent@cwc-i.com*
QuickHoney *www.quickhoney.com*
Andrew Rae *a@andrewrae.org.uk*
Shonagh Rae *shonagh@shonaghrae.com*
Jo Ratcliffe *jo@jocandraw.com*
Edward Recife *recife@misprintedtype.com*
Bernie Reid *me@berniereid.co.uk*
Rinzen *they@rinzen.com*
Lucinda Rogers *studio@lucindarogers.com*
Graham Rounthwaite *studio@grahamrounthwaite.com*
Harriet Russell *Harriet77@clara.co.uk*
Yuko Shimizu *yuko@yukoart.com*
Maja Sten *info@majasten.se*
Kerrie Jane Stritton *kerrie@kerriestritton.com*
Zissou *zissou@supernaturalstudios.com*
Kam Tang *hello@bigactive.com*
Jeremy Tankard *info@jeremytankard.com*
Gary Taxali *gary@garytaxali.com*
Patrick Thomas *info@patrickthomas.com*
Michelle Thompson *info@michelle-thompson.com*
Clarissa Tossin *ola@a-linha.org*
Jonathan Tran *create@pvuk.com*
Gina Triplett *gina@ginaandmatt.com*
Aude Van Ryn *audevanryn@onetel.com*
Lucy Vigrass *lucy@peepshow.org.uk*
Jesper Waldersten *jesper@jesperwaldersten.com*
Spencer Wilson *spencer@spencerwilson.co.uk*
Guillaume Wolf *luxurydarkly@gmail.com*
Ian Wright *mail@mrianwright.co.uk*
Andrew Zbihlyj *andrew@pieceofshow.com*

First published in Great Britain in 2006
This mini edition first published in 2010 by
Laurence King Publishing Ltd

4th Floor, 361–373 City Road
London EC1V 1LR
Tel: +44 20 7841 6900
Fax: +44 20 7841 6910
e-mail: info@laurenceking.com
www.laurenceking.com

A catalogue record for this book is available from the British Library.

ISBN: 978-1-85669-607-4

Printed in China

Every effort has been made to contact the copyright holders, but should there be any errors
or omissions, Laurence King Publishing Ltd would be pleased to insert the appropriate
acknowledgement in any subsequent printing of this publication.

Designed by Pentagram Design
Cover by Marion Deuchars and Angus Hyland